# THE SOUL OF
# Gift Wrapping

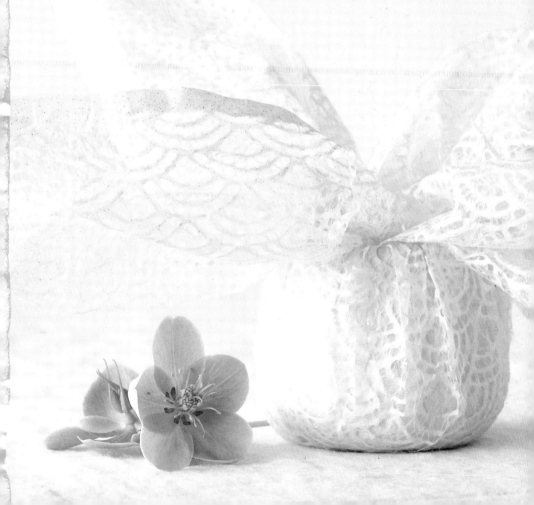

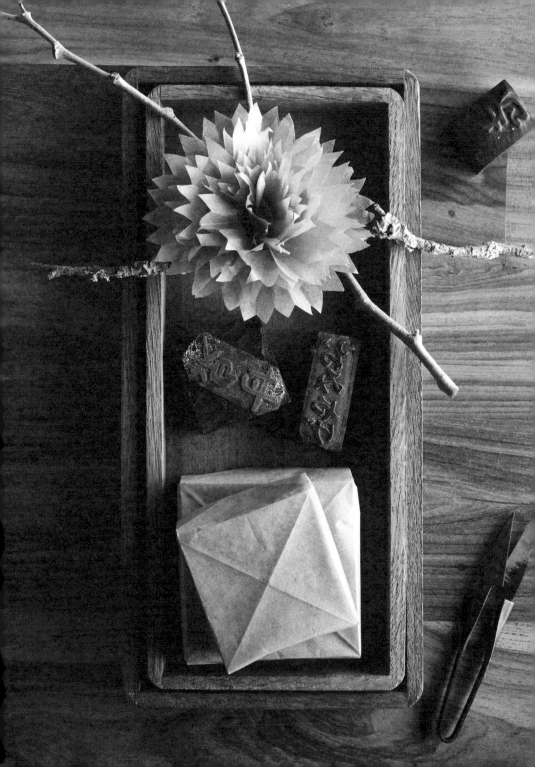

# THE SOUL OF
# Gift Wrapping

**CREATIVE TECHNIQUES FOR
EXPRESSING GRATITUDE,**
Inspired by the Japanese Art of Giving

*Megumi Lorna Inouye*

Storey Publishing

The mission of Storey Publishing is to serve our customers by publishing practical information that encourages personal independence in harmony with the environment.

**EDITED BY** Alethea Morrison and Deborah Balmuth
**ART DIRECTION AND BOOK DESIGN BY** Alethea Morrison
**TEXT PRODUCTION BY** Jennifer Jepson Smith

**COVER PHOTOGRAPHY BY** © Erin Ng, except for back (t.l.) by © Katie Newburn
**INTERIOR PHOTOGRAPHY BY**
© **Katie Newburn,** i, ii, v, vi b.l., viii, x, 6, 10, 13, 14, 17, 18, 25 t.l. & b.r., 26, 29, 30, 32, 34, 37, 38, 40, 42, 46, 49, 52, 54, 55, 56, 66–68, 85, 132, 150, 152, 165, 185–188, 197, 198
© **Erin Ng,** vi all but b.l., 3–5, 21, 25 t.r., 45, 50–51, 64, 70, 75 b., 76, 79 b., 80, 86, 88, 90, 93, 98, 101, 104, 106, 108, 111, 114, 116 b., 117, 120, 122, 126, 128, 130, 133, 135 b., 136, 138, 140, 142, 154, 157, 160, 162, 164, 166, 167, 171, 173, 174, 176, 178, 180, 181 b.r., 182, 192
**Mars Vilaubi © Storey Publishing,** 58–60, 62, 63, 65, 71–74, 75 t.l., 77–78, 79 t., 81–84, 87, 89, 91, 92, 94–97, 99, 100, 102, 103, 105, 107, 109, 110, 112, 113, 115, 116 t.l. & t.r., 118, 119, 121, 123–125, 127, 129, 131, 134, 135 t., 137, 139, 141, 144–149, 151, 153, 155, 156, 158, 159, 161, 163, 168–170, 172, 175, 177, 179, 181 t.l., t.r. & b.l., 183, 184
Additional interior photography by © Joanna and Michael Inouye, 22; © RodriFrancoMtz/Shutterstock.com, 25 b.l.

Text © 2024 by Megumi Inouye
Foreword © 2024 Beth Kempton

The information in this book is true and complete to the best of our knowledge. All recommendations are made without guarantee on the part of the author or Storey Publishing. The author and publisher disclaim any liability in connection with the use of this information.

The publisher is not responsible for websites (or their content) that are not owned by the publisher.

Storey books are available at special discounts when purchased in bulk for premiums and sales promotions as well as for fund-raising or educational use. Special editions or book excerpts can also be created to specification. For details, please send an email to special.markets@hbgusa.com.

**Storey Publishing**
210 MASS MoCA Way
North Adams, MA 01247
storey.com

Storey Publishing is an imprint of Workman Publishing, a division of Hachette Book Group, Inc., 1290 Avenue of the Americas, New York, NY 10104.

ISBNs: 978-1-63586-554-7 (hardcover); 978-1-63586-555-4 (fixed format EPUB); 978-1-63586-839-5 (fixed format PDF); 978-1-63586-840-1 (fixed format Kindle)

Printed in China through Asia Pacific Offset on paper from responsible sources
10 9 8 7 6 5 4 3 2 1

Library of Congress Cataloging-in-Publication Data on file

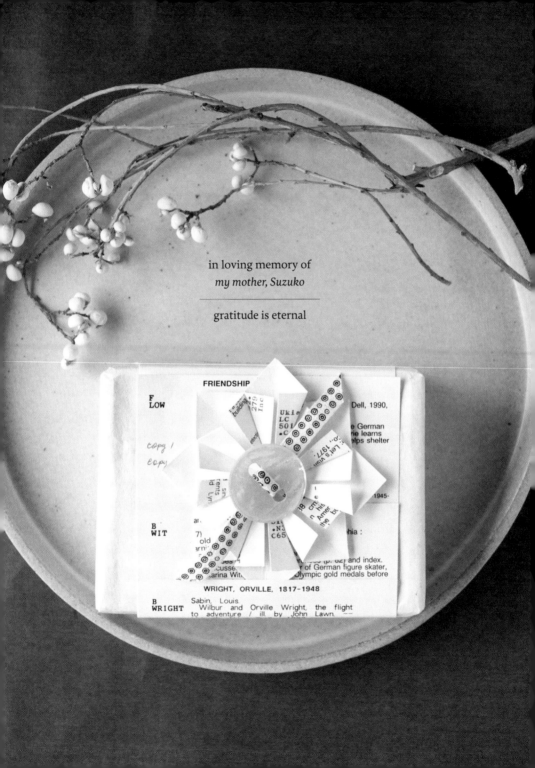

in loving memory of
*my mother, Suzuko*

gratitude is eternal

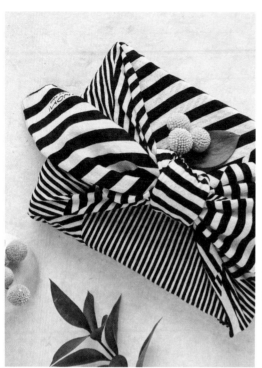

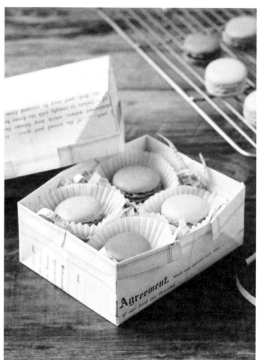

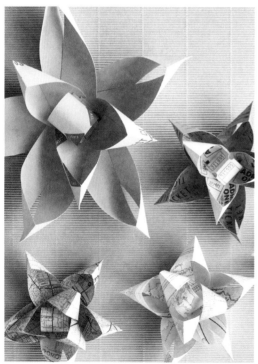

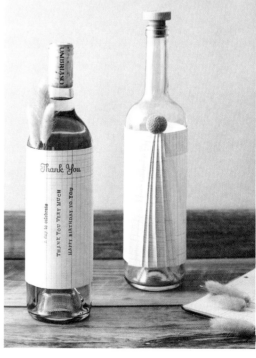

# Contents

## INSPIRATION, 4

Inspired by her bicultural upbringing and the traditions of her Japanese heritage, Megumi shares stories and examples of gift wrapping that explore the question of how we can wrap in an intentional way to nurture our lives and others.

## PREPARATION, 50

Learn about the tools, environmentally sustainable materials, and the basics of wrapping with paper and fabric.

## CREATION, 66

Follow step-by-step directions for wrapping and embellishing gifts of all sizes and shapes, including 25 designs for wrapping and 11 designs for embellishments.

# Foreword

BY BETH KEMPTON

Author of *Wabi Sabi: Japanese Wisdom for a Perfectly Imperfect Life*

As a child I thought that wrapping Christmas presents at Harrods in London must be the best job in the world, such was my obsession with making gifts beautiful. Even at a young age I somehow understood that thoughtful wrapping doesn't just make a gift look better, it makes it feel better, as if joy itself could be folded into the layers of paper and handed over.

Megumi Inouye understands this better than anyone I know. To her, wrapping is expression and offering, ritual and prayer, a practice of gratitude.

Having spent many years studying the art of Japanese life, I have come to understand that the best of Japan-inspired design has four elements: simplicity, utility, beauty, and story. Megumi's approach to gifting and writing has all those things, which is why her work speaks directly to my heart.

I particularly love the way Megumi weaves in the everyday. Nature finds, scraps of memory, and the discarded remnants of a well-lived life get tucked into the folds of her wrapping like paper poetry. May this be an invitation for you to do the same.

I hope this beautiful, soulful book will inspire you to slow down and enjoy every moment of wrapping and offering gifts. And in doing so, may those you love know just how much you care.

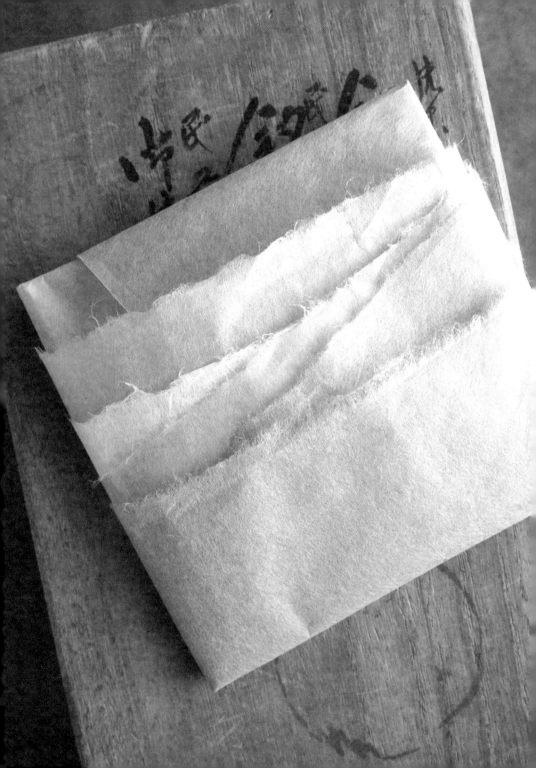

# How It All Began

Few, if any, books explore the why of wrapping gifts or consider what makes the act of wrapping meaningful to either the giver or the receiver. This book is the exception. It is inspired by the wisdom found within the cultural values and giving traditions of my bicultural Japanese American upbringing.

I vividly recall, when I was a young girl, the feeling of a summer breeze and smell of mothballs as I watched my mother open a chest full of kimonos. Layers of washi rice paper encased the kimonos, and the undergarments were wrapped with an air of gentle confidence that seemed to say "You, too, are worthy of appreciation and love."

My mother's hands glided over the wrapping paper carefully before slowly untying the string. She talked about the artisans of Japan who took thoughtful pride in their work to assure the protection of the kimonos. I could almost feel their labor of love.

I have no memory of the kimonos themselves but do remember the details of how they were packaged, the browned edges of the washi paper, aged from years gone by. The ritual of the unwrapping still mesmerizes me, and I recollect the elements in slow motion. Most of all I remember how this act transported my mother to a tranquil state of reflection.

The kimono chest was my mother's dowry. My grandmother spent her life savings on these hand-stitched kimonos so her daughter could start her married life with belongings of the highest quality. This gift held no use in my mother's new life in the US. With no appropriate occasions, my mother never actually wore the kimonos. Still, every summer, she gently unwrapped the kimonos, aired them out, then rewrapped them for storage. She did all of this with the utmost care and with feelings of deep gratitude. My mother often said she would never be able to repay her mother for all the sacrifices she had made.

Looking back, I realize that lying inside the memory of my mother and her kimono chest is, beautifully wrapped, a profound wisdom imbued in Japanese values and traditions. My love for wrapping and packaging has its origin in this memory, and the journey of this book is rooted in unwrapping and sharing the hidden treasures within.

Writing this book was the culmination of three decades of work bridging what I see as the best parts of the United States and Japan. It has been a true labor of love and purpose. Born and raised in the US by parents from Japan, my bicultural identity is at the heart of who I am. I've always felt blessed by my dual heritage, which gives me an extra pair of eyes that allow me to recognize the gems of both cultures and traditions. I owe my creative practice as a sustainable gift wrapping and packaging artist to my Japanese heritage, which considers wrapping to be a part of the gift itself, a reflection of the gift's meaning, and an expression of gratitude that can profoundly honor the recipient of the gift. Environmental consciousness is a natural extension of any gratitude practice. Our choice of materials for wrapping is an opportunity to honor the earth.

In the pages that follow, I share stories, personal discoveries, and historical context, uncovering why we wrap and what inspires me. Grounded in these principles of gratitude, I then share how to wrap, with step-by-step instructions for wrapping and embellishing any gift with intention and beauty.

I'm grateful for the opportunity to share the transformational, loving, healing, thought-provoking power of wrapping. The gift of gratitude is timeless and needed now more than ever.

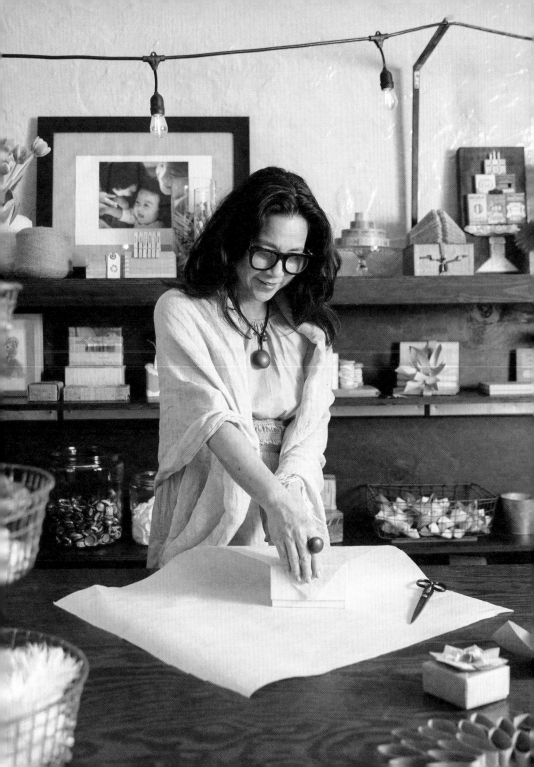

# Inspiration

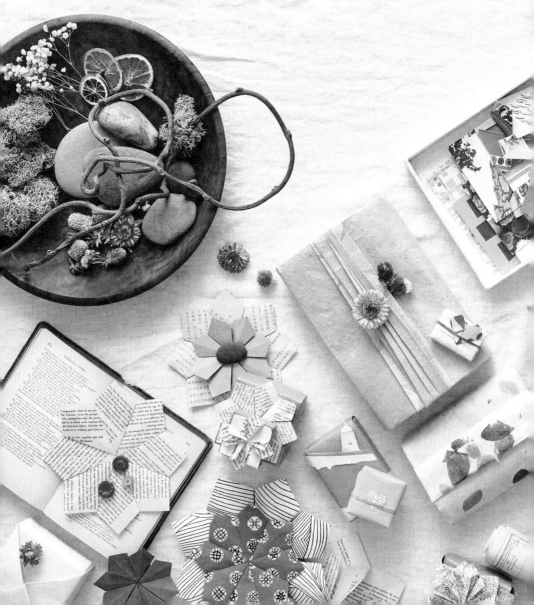

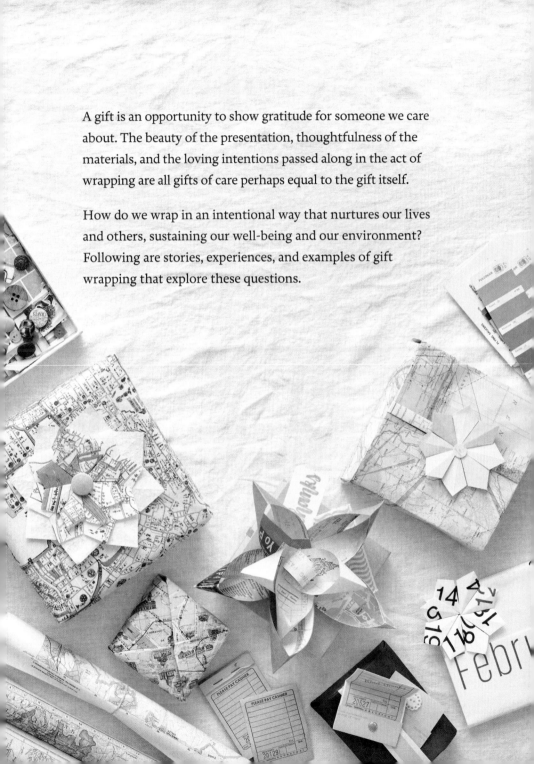

A gift is an opportunity to show gratitude for someone we care about. The beauty of the presentation, thoughtfulness of the materials, and the loving intentions passed along in the act of wrapping are all gifts of care perhaps equal to the gift itself.

How do we wrap in an intentional way that nurtures our lives and others, sustaining our well-being and our environment? Following are stories, experiences, and examples of gift wrapping that explore these questions.

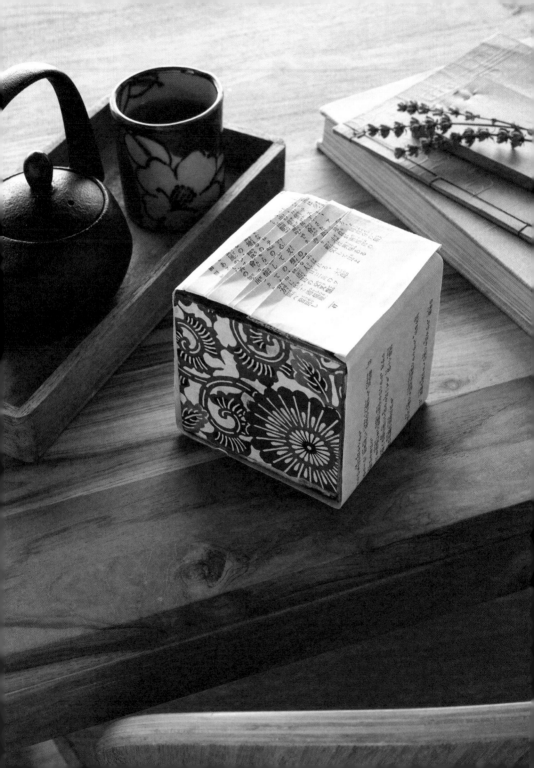

# The Joy of Simplicity

IDENTIFYING WHAT IS MOST ESSENTIAL

The wrapping of the very last gift that I would give to my father was simple. I remember pulling a sheet from the pile of loosely stacked newspaper on his table. I began to fold. A lifetime's worth of gratitude surfaced on my fingertips in those few minutes as I reflected on this quiet, humble, and unimposing man who devoted his life to his family. He let me be me unencumbered by societal expectations, making me feel accepted for who I was.

My father wrote and found fulfillment composing senryu, a Japanese form of short poetry highlighting observations of daily life. Like a photographer capturing visual memories with a click of a button, he found contentment documenting a fleeting emotion with a simple sentence. He devoted most of his time in retirement and after the passing of my mother to this art form.

His writing was a part of his life that he kept mostly to himself. I had come to know about it more deeply after he was given a terminal health diagnosis. As I helped him sort through his things, opening a drawer I uncovered notepads of his writings and a multitude of clippings of his senryu poems published in the Japanese American newspaper, along with cards, gift tags, and photos my brothers and I had given to him over many years.

During his illness, in between periods of rest, my father and I would share hot green tea along with his favorite rice cracker snack, senbei. I would bring out the newspaper clippings of his poetry and ask him to read back to me some of his writings. These moments gave me the long-awaited chance to open a dialogue and ask questions about his senryu poetry.

I mentioned his writings were like a diary of his memories and asked if any of the poems stood out. "Empty box of sweets, grandchildren

visiting" was one he shared, capturing a happy memory of a time spent with my children when they were young.

Inspired by an art exhibition I had recently seen, I began an art project collaging vintage papers and my father's senryu clippings onto wooden blocks. It wasn't finished; it was an ongoing project, so I'm not sure what compelled me to wrap an unfinished project this one day.

I placed my gift next to his teapot, the folded newspaper wrapping only a portion of the contents, with a bit of the gift exposed. There are no rules that say a gift must be completely wrapped in paper or elaborately packaged to be meaningful. Pared down to its essence, wrapping is simply a covering. It is through our hands and hearts, following the deepest of our instincts, that we make it into something of value.

He didn't open the gift right away as he approached the table. From the kitchen, where I was preparing a pot of healing dashi, stock made from fish and kelp, I caught a glimpse of him pouring his tea, the hot steam rising from his weathered, beloved teacup, the same one he used every day. A wool sweater, one I gave him many Christmases ago, hung on his now-frail body, even though the room temperature was mild.

There is an undefinable word in Japanese: *wabi sabi*. It is a philosophical construct, an aesthetic ideal, a way of life but also a way to view life appreciating the beauty found in the transient, imperfect, and simplicity. Wabi sabi is often associated with physical objects that have a worn, aged look and feel about them, but in her book on the subject, author Beth Kempton described it more deeply in the context of how one experiences life. "It is felt in a moment of real appreciation—a perfect moment in an imperfect world." She shares how the principles that underlie wabi sabi remind us "to look for beauty in the everyday, allowing us to be moved by it, and in doing so, feeling gratitude for life itself."

My father unwrapping the last gift that I would ever wrap for him was such a moment—perfect, yet imperfect, a beautiful sublime experience of melancholy. My newspaper wrapping, the only material I had on

hand, so raw, simply imbued with the sentiment of gratitude I could not speak, felt powerful in a way words cannot express.

I watched as he carefully took apart the newspaper wrapping, examining the folds with curiosity, and then held in his hands the wooden blocks lined with his poetry. We were connected in beautiful silence. These moments, sharing, the last gift that I would ever wrap for my father, was the closest to the feeling of the world of wabi sabi that I've experienced.

Surrounded by family and in his home, my father would leave our world in a way befitting of the man whose gentle and compassionate nature left only traces of his peaceful soul behind. Through his writing and life, editing his words and actions, eliminating the unessential, and bringing to light what is the most significant, he showed us the beauty and deep joy found in simplicity. There was nothing between us left undone or emotions unexpressed when he passed on.

*"Pare down to the essence, but don't remove the poetry."*
—LEONARD KOREN

## TECHNIQUES

BASIC BAND,
*p. 154*

ALTERNATING PLEATS,
*p. 147*

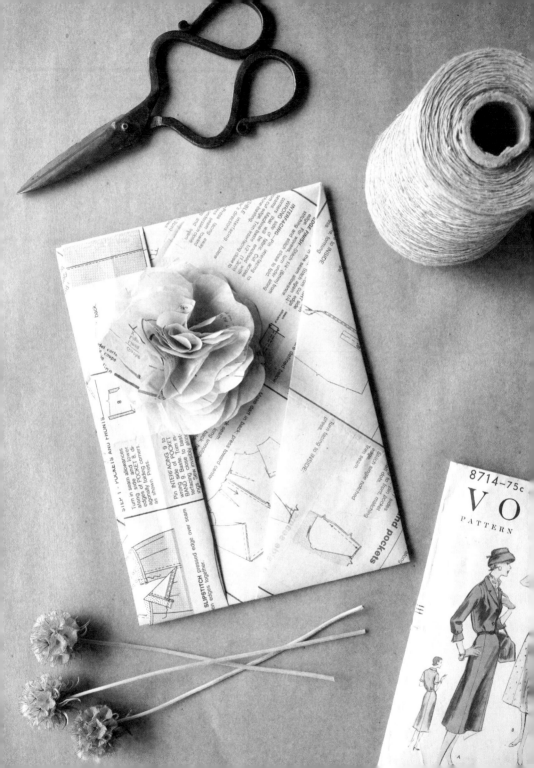

# The Power of Repurposing

The Japanese expression *mottainai* was often used in our house, usually in reference to not leaving anything on our plates. Though mottainai loosely means "wasteful," in its full sense the word references a regret that something or someone was not recognized for their everlasting worth. Raised to see and appreciate the value of things, I feel soulfully satisfied whenever I take an item viewed as no longer useful for its intended purpose, and with my own hands, attention, and creative imagination bring it back to life in new form, serving other interesting and inspiring objectives.

I am not a sewist, but old sewing patterns—the outdated ones often found in secondhand stores—are among my favorite materials to use for wrapping. As I unfold the fragile layers of tissuelike paper, I am reminded that their very survival suggests strength and durability. The bold lines that outline the pattern have an artistic quality; the workmanship of the patternmakers is clearly visible in the intricacy of the design. The texture and feel of the paper encourage layering and dimension. Its soft, flexible nature allows for movement, perfect for shaping embellishments.

I reached for sewing patterns to wrap gratitude gifts for the dear friends who celebrated a milestone birthday with me. At that time I feared maybe my best years were behind me and felt sad I had reached the age that my mother never lived past herself. I also felt that there was nothing I could give my girlfriends in a material way that would encompass the depth of my gratitude for their emotional support, especially during challenging life experiences.

---

*Repurposing unlocks beauty and transformational energy—materials, like people, have the potential for multiple destinies.*

This is when I'm grateful to the art of wrapping, where I can direct immense and immaterial feelings of gratefulness into something tangible. I decided not only to wrap the outsides of the boxes with sewing patterns but also to line the insides, a surprise much like discovering a beautifully patterned lining inside a coat. Wrapped in the folds, I enclosed a few of my favorite things: an inspired quote, spiced chocolate, floral scented lotion, a note of thanks. The flower embellishing the outside of each box captured a sense of uplift, something I'm grateful my girlfriends provide in my life. This project was a giving and receiving experience for me. Extending the life of the patterns—honoring their continued value—brought me a sense of peace and empowerment.

*"It's not about what it is—it's about what it can become!"*
—DR. SEUSS

## TECHNIQUES

DREAMS-COME-TRUE
POCKET ENVELOPE,
*p. 108*

TISSUE PAPER
FLOWER,
*p. 174*

# The Art of Scrap Wrap

I treasure my boxful of scrap papers—the cut-offs of an exquisite, textured washi paper I found in Japan, the remains of a train ticket that took me from a town of uncertainty to a city of possibilities. I love looking at my scraps like photographs, memories capturing a moment in time. In the remnants I find my story, and it's what ignites the inspiration for all that I create. They can be used for collage and integrated as part of the wrapping paper. They can become gift tags or handmade cards or embellishments. Witness for yourself the emotional surprise that comes from bringing together disparate pieces, akin to seeing your life in a whole new light.

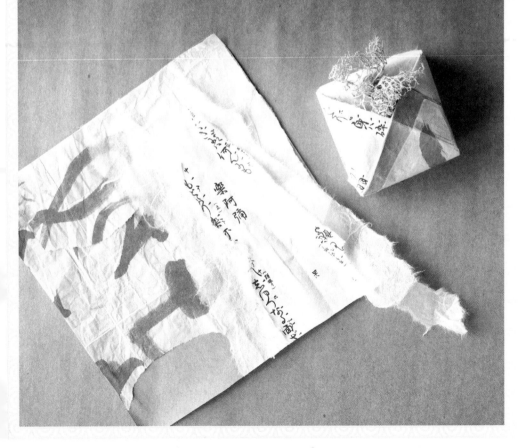

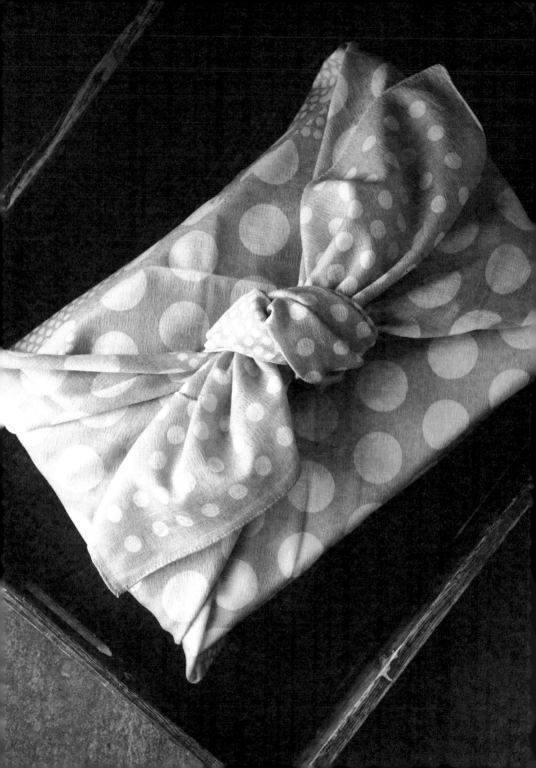

# The Comfort of Community

My initiation into the world of wrapping was not related to holiday or birthday gifts. As a child, I learned instead to associate wrapping with ordinary social gatherings and community picnics—our Japanese American rendition of the potluck. The seemingly endless food containers arranged on long outdoor tables were the homemade contributions of those who came. Interspersed among Tupperware, bowls, and lacquerlike boxes was an array of what looked like different-size gifts, wrapped in colorful furoshiki, or "wrapping cloth."

It would be the women, often the moms, who would signal the time to eat by milling around the table, uncovering the food. Taking the covers off the containers and unwrapping the furoshiki always initiated the Japanese equivalent of "oohs and aahs" and lots of commentary on each dish. It was then that everyone would reveal stories of family back home, exchange recipes for tsukemono pickled cabbage, and share tips on how long to stew root vegetables. The unveiling of the food created an opportunity not only for the joyful accumulating of recipes but also to learn about one another's lives.

My mother always had an animated air about her on the days before and after these community picnics. Her furrowed brow, brought on by daily worries, would soften, and something inside her would light up. During these get-togethers, the struggles and pains of everyday life while adjusting to a new country were not often spoken about, but they were inherently understood as a shared experience. Removed from their familiar connections in Japan, everyone deeply understood how much we as human beings need one another, a community of people gathering as friends. This was not only for practical support but for emotional sustenance and to bring needed laughter, enjoyment, and relaxation.

We may never truly know the value of gathering until the ability to gather is taken away from us by unfortunate circumstances, by moving to different shores, by a global pandemic. Wrapping for gatherings is a visceral, visual, and symbolic expression of gratitude, helping us to treat our social bonds as a gift not to be taken for granted.

I find myself wanting to re-create the scene of those long tables of furoshiki-wrapped containers. Adapted to modern times and living in an age of multicultural influences, I envision a table holding foods from a variety of cultural traditions. Each item's wrapping would reveal someone's or a family's unique artistic expression. In this way, the act of wrapping would collectively represent our collaborative appreciation of one another, our histories, and our family traditions. All of these layers would be wrapped into the grateful intentions we brought to the table.

*"The power of gathering: it inspires us delightfully*
*to be more hopeful, more joyful, more thoughtful;*
*in a word more alive."*
—ALICE WATERS

## Zero-Waste Meal Deliveries

While I was visiting a friend's house in Japan, she ordered lunch for us, delivered by bicycle. The meal came wrapped like presents in indigo blue cotton furoshiki. After we enjoyed the lunch, my friend left the boxes and furoshiki on her doorstep for pickup. I remember feeling extremely grateful to my friend for her welcoming hospitality and thinking "what an ingenious, waste-free delivery system and way of life."

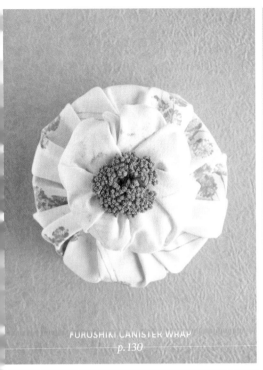

FUROSHIKI CANISTER WRAP
*p. 130*

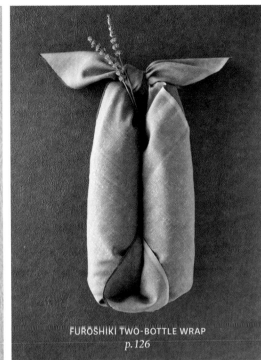

FUROSHIKI TWO-BOTTLE WRAP
*p. 126*

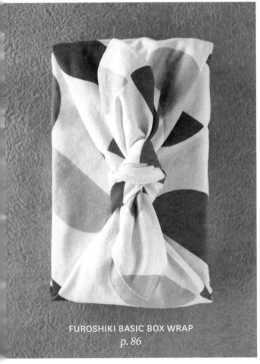

FUROSHIKI BASIC BOX WRAP
*p. 86*

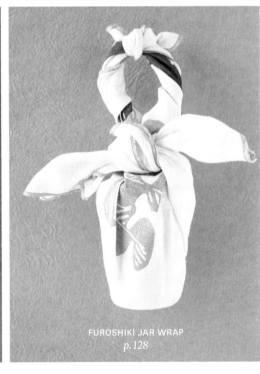

FUROSHIKI JAR WRAP
*p. 128*

# The Gift of Care

When my children were still young, we lived in Tokyo for a summer. I cherished discovering hidden gems—like the husband and wife selling fresh handmade tofu on a tiny street, tucked away from view and known mainly to those living in the neighborhood. I stumbled upon a produce store in a similar manner, taking a detour on my way home. The humble shop seemed like it belonged to another time and place. Situated in an alleyway, crates and boxes of unpolished vegetables and fruits were set out front, though Japanese grocery markets typically showcase only the most pristine produce. I entered in search of fresh herbs.

Deciding on radish sprouts, I handed them to the elderly Japanese shopkeeper with a worn-out apron, her hair wrapped in a scarf. Like a loving grandmother tending to her grandchildren, she took great care in packaging my modest purchase. "So it won't get smashed," she said, constructing a puffed pouch with her meticulous fingers. "They will have room to breathe now and they will remain fresh for you."

There is a cultural practice in Japan known as omotenashi, loosely defined as "Japanese hospitality," which involves looking after guests, foreign visitors, and customers with the utmost care and attentive detail. My own experiences have shown me, however, that its meaning runs much deeper, embodying a way of giving with a sincere heart and with no expectations of receiving something in return. Her unexpected care in wrapping my purchase felt like the essence of omotenashi. There was no logical reason to take this kind of time to wrap a grocery parcel unless the woman simply cared that I enjoy my greens in the best way possible.

Something transformative happens in the presence of this kind of genuine consideration. When thoughtful action is made with no

expectation of benefit or even acknowledgment, the receiver is overcome with immense gratitude. She elevated my ordinary purchase into an extraordinary memory.

At the produce shop, I offered my words of thanks in the most heartfelt way that I could. While normally I might have just thrown the item I purchased into my tote bag, I found myself cradling this small, wrapped package in my hand as if carrying newly hatched eggs from a bird's nest. I walked home with a less harried gait, reflecting that the only way to honor such generosity of spirit would be to pay it forward.

*"The most ordinary activities, carried out with mindfulness and art, have an effect far beyond their apparent insignificance."*
—THOMAS MOORE

## TECHNIQUES

FAVOR BAG,
*p. 140*

NATURE BAND,
*p. 160*

# *The Gift of Words*

I often wrap notecards as I would wrap a gift—usually a simple band around the envelope, a muted color, thin string holding the band in place. I almost inevitably add a simple flower, the quiet but striking ones that grow unnoticed on the side of a road.

Yūgen is an important concept in Japanese aesthetics, poetically described by the fifteenth-century monk-poet Shōtetsu as the "quality suggested by the sight of a thin cloud veiling the moon or by autumn mist swathing the scarlet leaves on a mountainside." That essence is how I feel about wrapping words. The wrapping becomes the veil for my thoughts, too personally and deeply felt to expose directly.

Confronted by jarring texts and tweets, void of filter, no accounting for impact, I become centered and soothed when I put my sentiments to paper with slow care and thoughtfully wrap them. I remember that words matter, how we treat our words matters, and how we share them with others matters.

*"One kind word can warm three winter months."*
—JAPANESE PROVERB

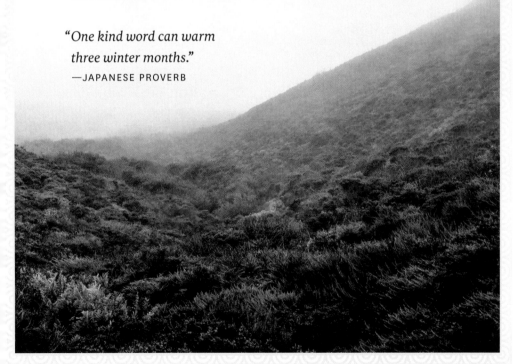

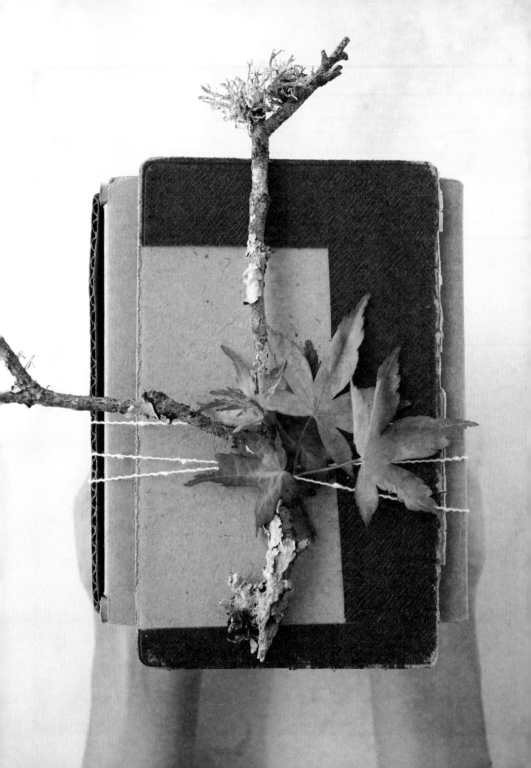

# A Tribute to Nature

R ice crackers wrapped in woven strips of bamboo sheath, oak leaves gracefully folded to wrap rice balls, a single bamboo leaf turned exquisitely into a sculptural art piece wrapping a sweet bean cake—I fell in love with the images featured in Hideyuki Oka's book *How to Wrap Five Eggs*. Reading about the tradespeople, farmers, and artisans of old, traditional Japan integrating nature harmoniously into their daily lives through the art of wrapping and packaging captured my imagination.

Oka described the artistry of ancient Japanese wrapping as "communion between man and nature." The profound feelings of reverence and gratitude for nature documented in the book led me to question how we can creatively integrate natural elements into contemporary giving practices to express our appreciation for the enormous gifts the earth continually bestows on us. Through our ritual of wrapping, is there a way for us to inspire ourselves and others to reconnect with nature?

As a regular, mindful practice of gratitude toward nature, I now explore the outdoors with an eye toward what I can integrate into my giving and gratitude rituals. I've come to understand how being mindful of the seasons and incorporating seasonal elements of nature into my wrapping brings attention to nature's rhythms.

Discovering a leaf in seasonal transition while on a walk with my dog, I became suddenly aware, in the way a painter might observe nature's language of expression through its colors. Playing out on a singular leaf

---

*Incorporating elements of nature in gift wrapping is an eco-friendly alternative to using store-bought accessories that often wind up in the landfill.*

were the yellow and orange pigments making their way to the surface, fading out the summer's green into the background. The amber colors, bleeding into the leaf like a watercolor painting, gracefully and humbly taking their rightful turn in the light, were letting us know the days were getting shorter, temperatures were dropping, and fall was coming.

Brought together on a gift, a broken branch, a fallen leaf, the weed that is the forgotten flower, exposes nature's beauty up close in all its intricate fleeting detail. What are some other examples of how we can take a moment to notice nature for all its offerings? Can sharing this appreciation with others by passing it on as part of wrapping a gift impact how we collectively treat our environment?

## The Honorable Harvest

Mother, Indigenous scientist, and author of *Braiding Sweetgrass*, Robin Wall Kimmerer provides guidance on how we can approach natural elements respectfully in a set of teachings she calls "The Honorable Harvest." Among her recommendations are to minimize harm, take only what we need, use everything we take to avoid waste, share what we have taken, reciprocate the gift with respect, and be grateful. Of all the guiding principles, she attributes gratitude as the most powerful tool we have, a tool she says that in our consumer-driven society has conservation value because it brings about a reciprocal relationship with all beings, reminding us that humans and nature are interconnected.

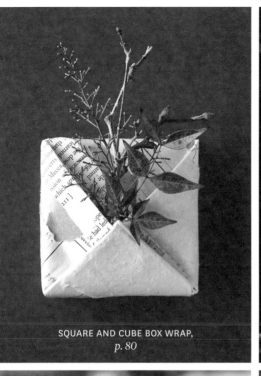

SQUARE AND CUBE BOX WRAP,
*p. 80*

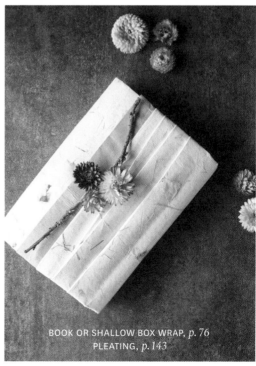

BOOK OR SHALLOW BOX WRAP, *p. 76*
PLEATING, *p. 143*

ready, willing and able to become women. Good fun from an unknown cast. Thankfully, the local censors left it alone. 1999.

# Payment in Gratitude

ADDING SOULFUL INTENTIONS TO GIFTS OF MONEY

I t wasn't a fancy hotel—merely a place that would house me comfortably for the needed time, with a bed and generic furnishings. Yet, as I went about the normal routine of unpacking, I noticed how precisely the things around the room had been placed, tucked, pulled, and patted down. The crispness of the towel carefully folded with an extra flap to house the face towel, the sheets tucked back ever so slightly so the climb into bed would require one less step before slumber; these subtle details caught my attention. There was an intentional thoughtfulness in the way the room had been prepared that sent a message of comfort, encouraging me to slow down and feel welcomed.

We often overlook and fail to acknowledge the silent, unseen caretakers who contribute to our well-being. How do we express our appreciation to those seemingly invisible people who bring something of importance to our lives? What simple actions can we take to show that what they do matters, and we don't take it for granted? My own heart responded to the thoughtfulness of the unseen hotel housekeeper. I utilized paper I found in reach and began folding with the intention of expressing my gratitude for the care that I had received from this silent stranger. I placed a gratuity tip inside my wrapping, added a handwritten "thank you" message on its flaps, and placed it on the bedside table.

I would never know the impact of this gesture, but I imagined the possibility that the discovery of my little package would elicit a smile, and perhaps return the feeling of being cared for and acknowledged that I had come to feel during my short stay in that room.

### TECHNIQUE

LAYERED WITH LOVE ENVELOPE, *p. 106*

# How to Receive a Gift Gratefully

In Japanese culture, the act of wrapping a gift is often explained as "wrapping of the giver's heart" or "wrapping of the heart" and is an integral part of the gift exchange. The thoughtfulness of giving a gift and the heartfelt care taken in wrapping it appropriately spotlights the generosity of the giver, but those who graciously receive a gift are giving generously from their hearts in return.

In Japan, the grateful way to receive a gift is with both hands. Gifts are unwrapped slowly as if taking gentle care of the emotions of the giver. Often the elements of the wrapping, the string or tassel, the washi paper, are saved and stored for reuse, savoring the beauty in the details that are featured in the wrapping itself.

There is a silent but powerful message conveyed in the ritual of receiving gifts this way. In being literally and symbolically present, extending both our hands, we express gratitude for having received, for being thought about, and we attach value to the meaning behind the gifts we are given. As Zen Buddhist Leonard Scheff said, "In receiving graciously, in accepting whole-heartedly, we are also giving. We are allowing the giver to enter into relationship with us, acknowledging his good will, and sharing in our common humanity and interdependence."

While the material gift has a shelf life and may soon lose its monetary value, the feelings and intentions given with it—and reciprocated—sustain our collective well-being. Herein lies the real beauty and magic of a gift.

> "Until we can receive with an open heart, we
> are never really giving with an open heart."
> —BRENÉ BROWN

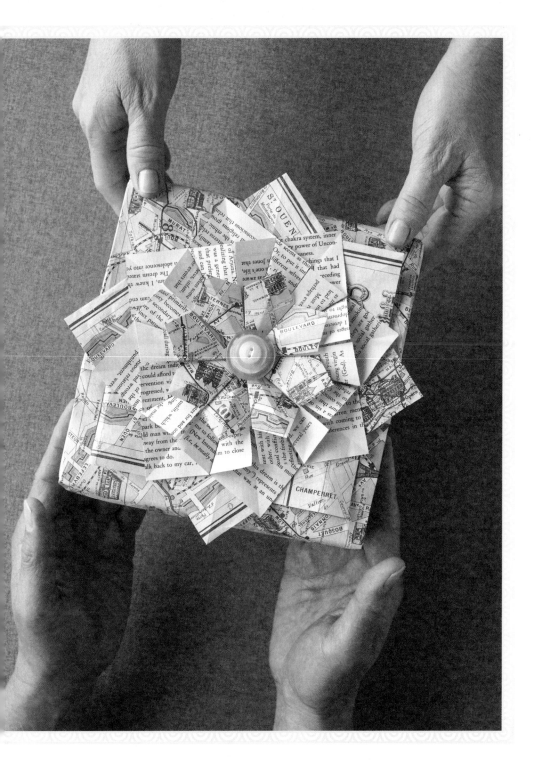

# The Friends Next Door

I n the countryside of Japan, people often grow their own food at home. Neighbors engage regularly in what is called susowake, which means "to share a portion of what you have with others." The exchanges serve as a way to socialize, keep up with happenings in the community, and share abundance while avoiding waste.

The advancement of technology has allowed us to connect with the world at large, but we often overlook the companionship and support available locally, in our own neighborhood. Not being able to gather with people and friends outside my immediate household during the pandemic heightened my awareness and appreciation for the people who live nearby. With so much out of my control, I took comfort in wrapping simple gifts. Leaving my thoughts of gratitude on the doorsteps of my neighbors resulted in a continual circulation of homemade, homegrown gifts. A neighbor thoughtfully shared pears from her tree. I baked and wrapped an olive oil pear dessert for her in return. I would later find a jar of salsa tied with ribbon and left in my herb planter.

Gifting and wrapping in this context awakened me to a new gratitude practice. Unlike gifts for holidays, birthdays, or other celebrations, there were no expectations or obligations, just spontaneous acts of mutual appreciation.

It shouldn't take a global crisis to get to know our neighbors. Who is in close physical proximity to us that we have been overlooking? Interconnectedness is available wherever we seek it.

**TECHNIQUE**

BRIMMING WITH BOUNTY GIFT BAG, *p. 133*

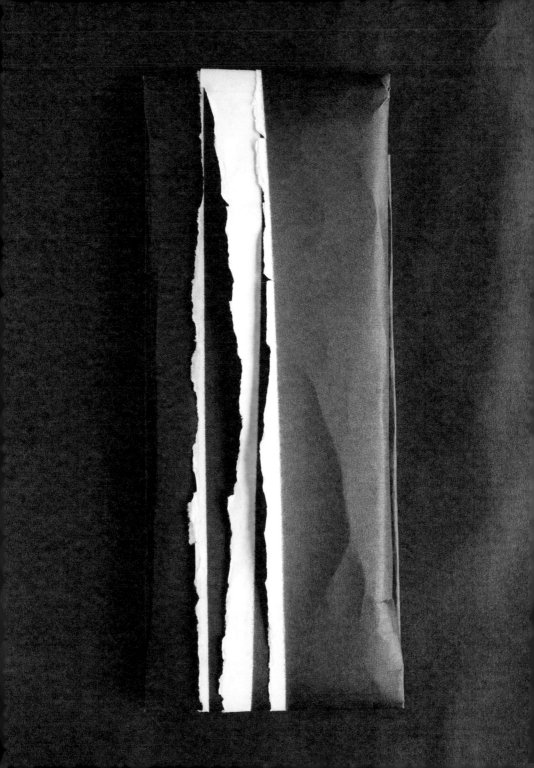

# An Embrace of Imperfection

Kintsugi is a Japanese art of mending broken pottery that treats breakage and repair with reverence, as a part of the object's story. The broken areas of a ceramic piece are put back together using lacquer and gold or silver powder, highlighting and adorning the flaws rather than hiding them.

Kintsugi came to mind when I accidentally tore the washi paper I was using to wrap a set of teacups. I thought to accent my accidental rip instead of covering it up or starting over. The torn edges resembled a wet feather, creating dramatic contrast between the white paper and the dark background of the box. It looked like a painting of a snowcapped mountainscape or waves of white against the dark sea. It was beautiful.

My mistake unlocked for me a wealth of creative potential, fueling a practice of intentionally incorporating tears into gift wrapping. Could tears in paper deliver a figurative message that encourages us to find beauty instead of pain in imperfections—not only in objects but also within ourselves and others?

I reflected on this as I wrapped a book for a dear person in my life who was overcoming hardships at the time. I embraced the theme of "beauty in the tear" to show her how I thought the areas where she felt broken were in fact what made her special—the very part of her I was grateful to know. Within the folds of the torn paper, I placed a sprig of baby's breath and held the wrapped gift in my hands for a moment before giving it away. I hoped my healing intentions would be felt and understood in some form.

## TECHNIQUE

TEARING, *p. 151*

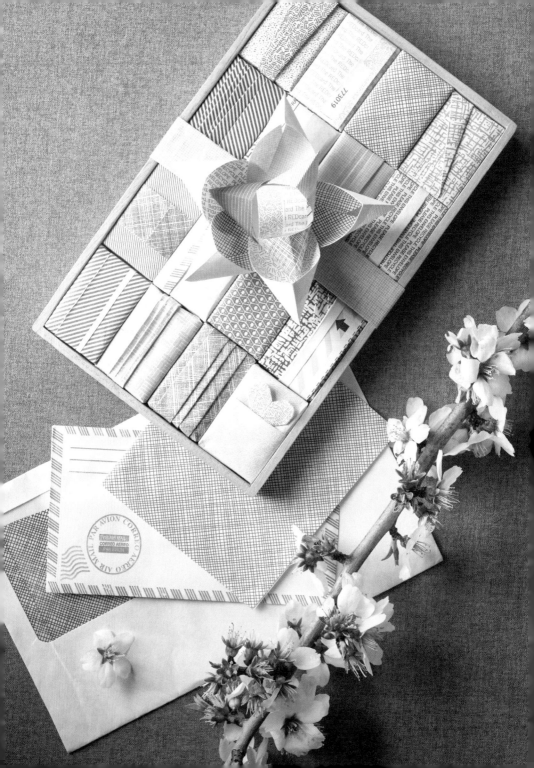

# The Essence of the Gift

T he art of wrapping embodies a similar quality as a Japanese shoji screen, the traditional translucent screens on wooden lattice frames that serve as doors, screens, or windows in Japanese homes, temples, and ryokans, or inns. Both wrapping and shoji are designed to bring focused attention to something intentional, simultaneously framing and revealing an object or an experience as special and worthy of sharing.

I first considered this connection during a visit to Japan many years ago, when I gently slid open a shoji screen on a window above where I was submerged in an onsen mineral bath. Cherry blossoms fluttered across the entire rectangular opening. The scene took my breath away, leaving me in a state of floating gratefulness. Whoever placed the window in that precise location did so with the intention of directing bathers' attention to a special experience of spring. It was as if that person were whispering "slow down, take a moment, appreciate the beauty in your life." It was the Japanese cherry blossom version of the American adage "stop and smell the roses."

There is a certain kind of picture window–style shoji called yukimi-shoji, which literally means "snow viewing window" and is strategically designed to bring one's eyes and attention to a landscape. Everything distracting, such as the road or the building next door, is cut off from view in order to bring focus to the snow falling on the ground. While the term refers to snow and winter, the design concept can apply to fall leaves, morning dew in summer, cherry blossoms in spring, or whatever is the intended natural focal point.

I had an opportunity to bring this shoji approach to my own gift wrapping several years ago, as part of a twenty-fifth anniversary gift for my husband. As I contemplated how to mark the milestone occasion, I

recalled the many road trips we had taken together over the years and how he always drove. We would invariably wind up talking about our children, or our dog, but also came to know a lot about each other on those long car rides to Lake Tahoe, along the Highway One coastal route, or passing through Mount Shasta to get to Oregon to see our daughter attending college. I realized these and other seemingly insignificant bonding moments meant so much to me over the years.

As each flashback surfaced, I wrote them down on a small card, then wrapped each one separately and put them into repurposed envelopes originally meant for hardware nails—perfect for a handy man who can fix almost anything around our home. Taking the time to hold each individual written memory in my hands and being mindful with every fold helped me remember what something meant on a given day or specific time in our life.

In this way the art of wrapping helped direct my attention to feelings of gratitude. Wrapping helped me to pause and linger, focusing my thoughts on the joyful aspects of 25 years of marriage and raising three children. Cut off from view was everything distracting: the lack of time, feelings of stress, endless to-do lists that prevent us from appreciating all the good things that are in front of us. How lovely it was to be redirected, even for a fleeting moment, to the metaphorical view of snow falling on the ground.

### TECHNIQUES

BOOK OR SHALLOW
BOX WRAP, *p. 76*

PLEATING,
*p. 143*

## The Subtle Reveal

Encountering traditional confectionery shops in Kyoto—where packages are wrapped only partially—helped me discover how a subtle reveal can be very effective. One purpose of wrapping is to hide the contents, gifting the element of joyful surprise along with the actual object. But is our objective always surprise? Does the gift need to be completely wrapped for it to hold intrigue? There is an understated beauty in the art of gently revealing something that provides an essence of what lies within. It leaves room for the imagination to savor, appreciate, and discover the layers of a gift's intended meaning.

> *"Less is not necessarily more....*
> *Just enough is more."*
> —MILTON GLASER

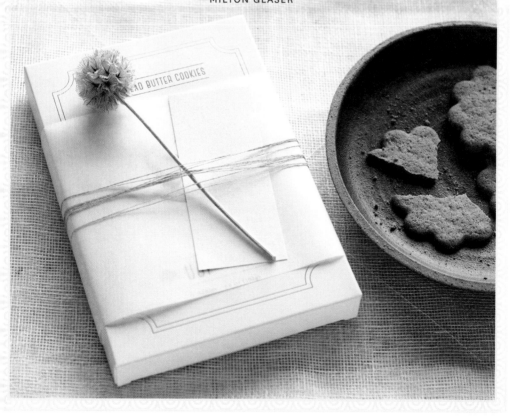

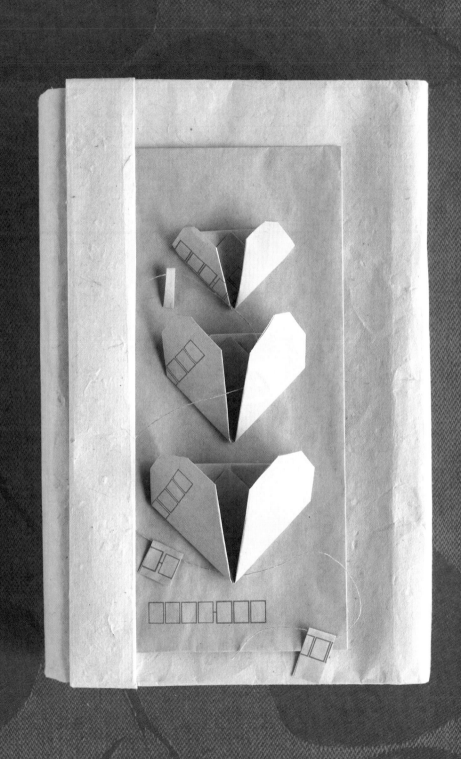

# The Heart of Gratitude

TENDING TO ONESELF AND OTHERS

Whenever I face something of importance that makes me anxious, I hear my mother's voice, a gentle directive to "prepare your heart." In Japan there are two words for the heart. One is *shinzou*, which refers to the physical organ of the heart, and the other is *kokoro*, which not only encompasses how we feel, what we think, and our intended meaning but also influences the landscape of our surroundings. I see what my mother was advising. In order to do something well, accomplish something of importance, there is the matter of tending to one's heart. Being calm and centered, and approaching whatever we do with the right intentions, impacts the outcome.

Kokoro becomes visible through our actions, revealing itself in the things we do, create, make, and give. I focus on happy and peaceful thoughts, helping others, seeing the good in people, and practicing forgiveness. I aspire to be more grateful, kind, compassionate, giving, and to appreciate the people and the world around me. My heart, making its way through my hands as I fold paper, fabric, and materials, is reflected in my wrapping. In the words of writer George Bernard Shaw: "You use a glass mirror to see your face; you use works of art to see your soul."

Whenever I wrap a gift as an expression of my soul, I realize I am also tending to the memory of my mother. It's as if the art of wrapping is there to teach and remind me to work on being my best, fullest version of myself. "Tend to your heart and that of others." It's as if I hear my mother's voice sharing a mystical secret directing me to the source of all of life's answers.

**TECHNIQUE**

ORIGAMI HEARTS, *p. 178*

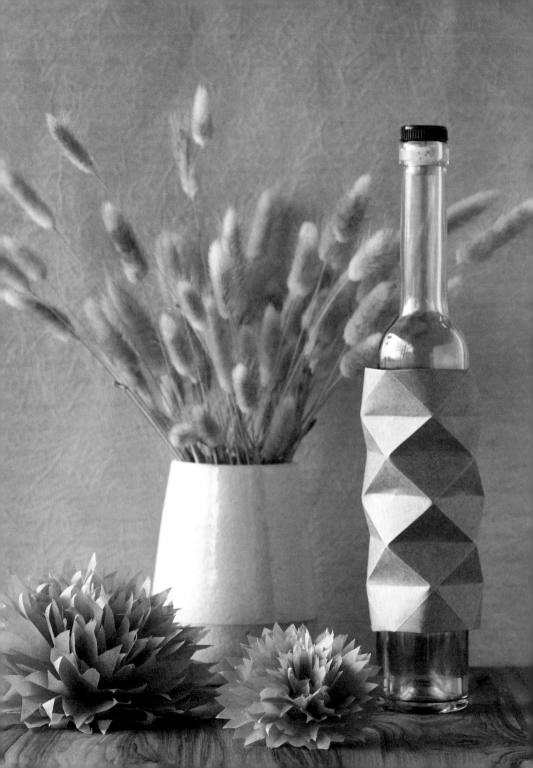

# The Art of Origami

Going back as far as the Heian era (794–1185) and in the Muromachi era (1336–1573), the Japanese aristocracy and high-ranking warriors were expected to learn techniques for folding handmade washi paper to wrap gifts. The craft was called orikata, meaning "folded shape" or "the way to fold for wrapping." Many variations of predetermined folded forms and structures were designed to wrap specific items such as fans, incense, or even money. These forms were mindfully molded to the shape of certain objects and were considered the proper way to express respect and thoughtfulness not only toward the receiver of the gift but also for the item being wrapped, reflecting the sincere feelings of the giver.

As washi paper became more affordable and accessible during the middle of the Edo era (1603–1867), orikata widened into mainstream Japanese culture and the activities of daily life. By the time of the Meiji period (1868–1912), paper folding became a form of common recreation, opening up the invention of fun shapes such as boats or hats and birthing the art of origami we know today.

That the practice of wrapping gifts is the predecessor and inspiration for origami was a revolutionary discovery for me. What if wrapping a gift didn't merely cover it, but became instead a creative exploration of shape and structure? Though origami projects tend to have detailed, complicated instructions that deliver predictable results, I've found that mastering a few basic techniques opens a world of creative possibilities for wrapping gifts.

## TECHNIQUE

 AKARI BOTTLE WRAP, *p. 122*

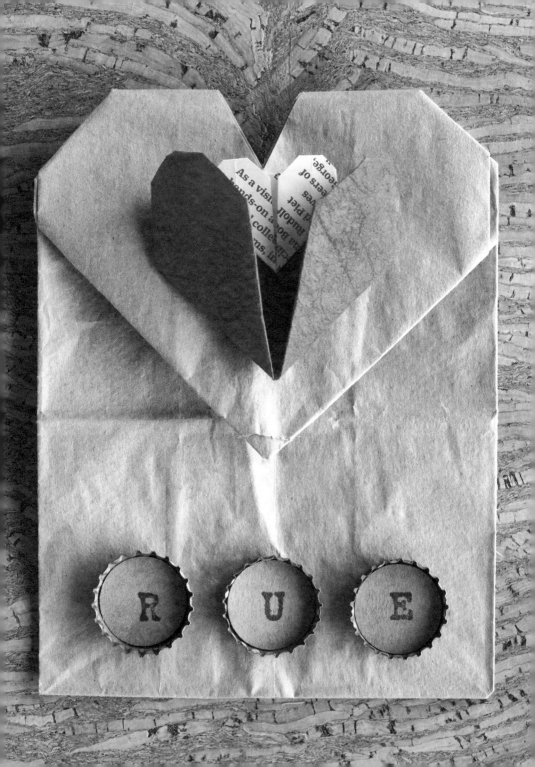

# The Love of Animals

When our dog Rue's heart gave way, we were at home, allowing us to keep our promise to be there for her last breath. On this day at sunset, hues of vibrant orange, dusty pink, and purple emerged amid the clouds unlike any we'd seen before. Arriving at the house in time to say goodbye to Rue, our children were able to join us in witnessing this spectacular display of nature's generosity, the sky comforting us in the way we most needed at the time.

Many of us have experienced the grief of saying goodbye to a beloved animal companion, who showed us the meaning of unconditional love and loyalty without ever speaking a word. The loss of Rue, rescued from a shelter over a decade earlier, was emotionally painful and intense. The void of her absence reminded us how much she gave us every day. If you have ever loved animal companions, I know you understand the heartbreak of losing them.

From this love of dogs, and all the animals that touch our lives so deeply, I have a confession. I wrap (sustainably) for my dogs. It is true. I wrap for our family's and friends' dogs as well. There is no rational explanation. I can only hope that the uplifting energy and love around wrapping and unwrapping a gift is something dogs can share and feel. I hope you experience the unreasonable but immense joy it generates.

One of our most cherished memories, in fact, is wrapping little gifts for Rue, gathering the kids around the table to celebrate her birthday. Remembering her face as we unwrapped her gift of dog treats still makes me smile.

*We treated our dog Rue as a valued member of our family*
*in every way. Because she was.*

Wrapping as a practice of gratitude is reserved for those who deserve our appreciation. We often neglect to acknowledge the ones who give us the most. It's only fitting that we bestow our pets with the honor they deserve for all the goodness they bring into our world.

*"We can only be said to be alive in those moments when our hearts are conscious of our treasures."*
—THORNTON WILDER

## TECHNIQUES

WITH ALL ONE'S HEART GIFT BAG, *p. 136*

ORIGAMI HEARTS, *p. 178*

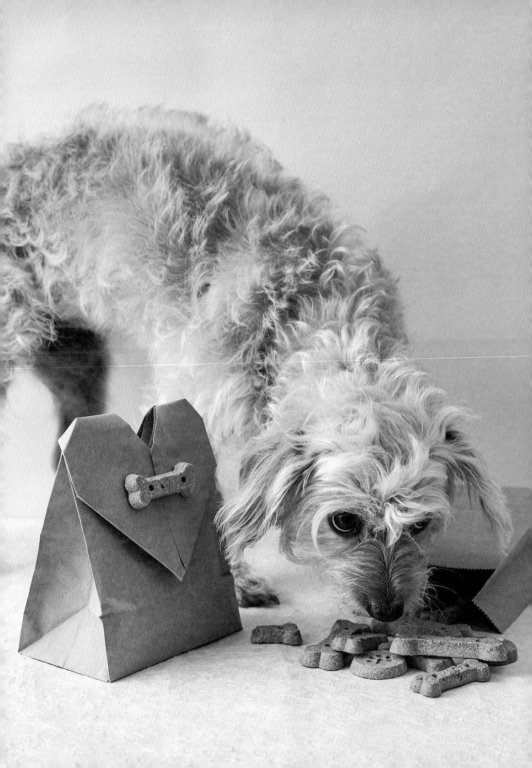

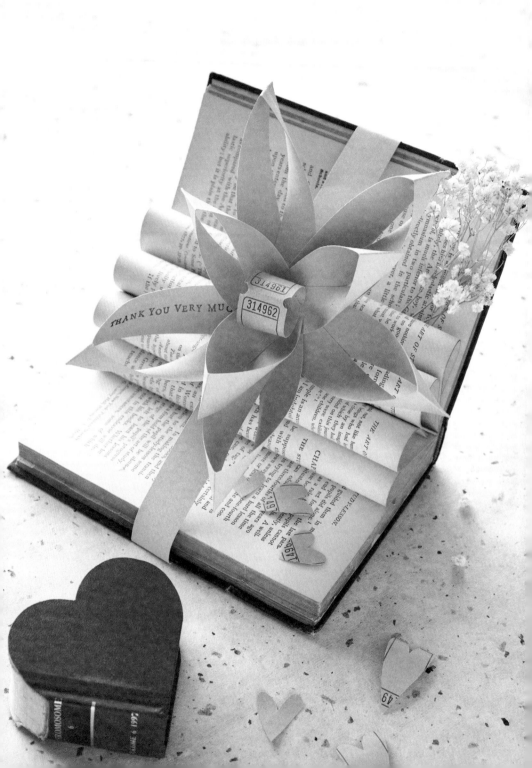

# A Symbol of Gratitude

Ribbons and bows as part of gift wrapping are not a traditional Japanese design. My personal introduction to the shiny, alluring, colorful ribbon bow was when I received a birthday party invitation in the first grade. I waited with excitement to be driven by my father to the local drugstore, where I perused the gift wrap section as though I were picking out candy. At that moment, the bow became for me, as it already was for so many around the world, the defining symbol of a celebratory gift.

Many years later, with a heavy heart, I read research on the harmful environmental impact of unrecyclable synthetic ribbons and bows that end up in our landfills. According to the National Environmental Education Foundation, Americans discard an estimated 38,000 miles of ribbon every year, more than enough to wrap around the entire planet.

Symbols are powerful. They become references for society and guide culture. Even the emoji for gift is a box with a bow. What if we didn't have to reject the iconic gift bow? What if I could create a sustainable version? As I approached this creative project, I sought to connect to *monozukuri*, a Japanese word meaning "the way to make things," which historically and philosophically has a deeper meaning that pays tribute to the spirit of master artists and crafters as well as their dedication to making things of lasting value and benefit to society.

I began by holding a traditional premade shiny red ribbon gift bow in my hand. I examined the folds of its design, noticing how it bloomed like a flower. I could feel its allure. I wanted to know its story and appreciate it for what it *is* before starting to reimagine it in any other way. I wanted to connect with the spirit of my intentions and enter the process with care and responsibility, ensuring that what I made was infused with depth and quality. I saw this as a "giving" way to approach my making,

attuned to being mindful of the value I would bring to the world with the remade bow I would create. Beginning from a place of gratitude allowed me to appreciate the bow's history before embarking on an innovative process of creating something new.

Eventually, I decided that it was important to retain the integrity of the bow's shape. I hoped this would make it less challenging for people to let go of something so ingrained in our culture of giving.

From reused file folders I designed a template, which I then applied to upcycle everything from old maps, envelopes, and ticket stubs to zippers and wallpaper. Repurposing a variety of materials presented me with many creative opportunities for expression. I got the idea, for example, to honor a music teacher with a bow made from old sheets of music. I also put together used tickets and maps from a trip with my daughter to create a bow reminding me of what an incredible gift we shared. In the way that some people might look back on a journal to see how or what they were thinking at any given moment in their life, I look back at my gift bows.

I further developed the gift bow by combining it with words. For example, I pulled paper from a discarded book of synonyms and antonyms to create ribbon strips highlighting words with positive messages. When my mother-in-law had major surgery, our family wrote loving and grateful messages on a gift bow's strips as part of the way we celebrated her return home from the hospital. What is it that we want to communicate when wrapping our gifts? How can we be more intentional with our giving? Can ribbons be messengers for our intentions?

TECHNIQUE

GRATITUDE BOW, *p. 167*

# Channeling the Artist Within

Have you ever thought of wrapping gifts as a canvas for artistic expression? Explore how color, texture, and ways of folding can reflect your intentions of gratitude toward the recipient of your gift. As you start to wrap in this way, your inner artist will reveal itself. The ephemeral quality of wrapping makes an artistic effort less daunting, almost experimental in nature. Seek out and have faith in the artist that lies within you!

*"An artist is not special. An artist is an ordinary person who can take ordinary things and make them special."*

—RUTH ASAWA

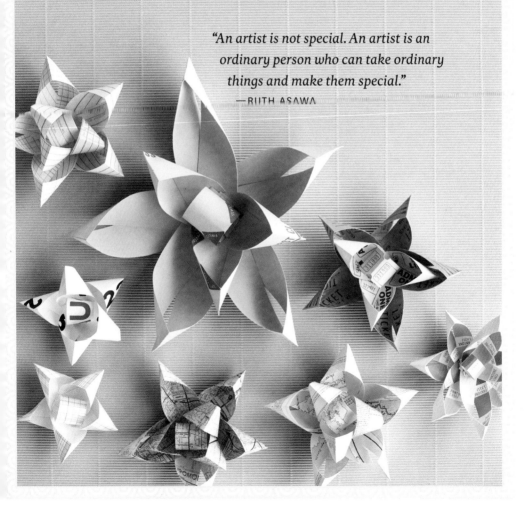

# Preparation

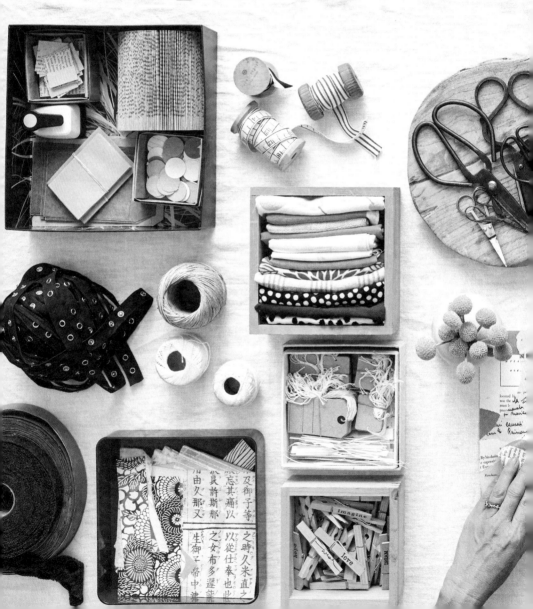

Wrapping gifts initiated by feelings of gratitude is often spontaneous, the impulse coming upon us unexpectedly. Preparation involves having some tools and materials ready at hand as well as the emotional and physical space to foster creative ideas and grateful feelings.

I curated the wrapping techniques in this book so that minimal tools are needed, and I share ideas for creatively repurposing materials all around you. In this way, wrapping as a way of expressing gratitude can be easily and thoughtfully implemented at any time, in any place.

# Tools

If you own a pair of scissors, you are ready to wrap, but I have a few optional favorites to share.

» *Hole punches:* If you have one tool other than scissors, a ⅛" or ¼" hole punch is my recommendation. It's helpful for making holes to insert brass fasteners or other binding materials.

» *Bone folder:* Popular with origami enthusiasts, bookbinders, and other paper crafters, this tool is great for creating smooth, firm creases when folding.

» *Paper knife:* Originally made to slice open the pages of handmade books, this tool is great for cutting folded paper, such as trimming rectangles into squares.

- » *Wrapping paper cutter:* This tubular tool with an embedded blade fits over a wrapping paper roll and delivers a straight, clean edge. You can also slide it across flat sheets for cross-cuts.
- » *Guillotine paper cutter:* The heavy-duty steel blade slices through stacks of paper in one pass.
- » *Circle punch:* Punches make it easy to neatly cut shapes for embellishments such as tags and bindings. Miscellaneous shapes, such as hearts, are available.
- » *Rubber stamps:* An easy, creative way to print design elements on your wrapping paper, gift tags, and notecards.

Keeping all your wrapping tools together and readily available in a basket or drawer will help to activate your thoughtful intentions with better ease.

## Wrapping Without Tape

Prepare to be surprised! Tape is not used in any of the wrapping techniques featured in this book. There is no invention more useful for holding wrapped gifts together than tape. I love tape. And yet, many of my workshop participants, community leaders, and clients have come to me for sustainable wrapping solutions over the years, and they inspired me to look deeper. I'm grateful they brought to my attention the need to eliminate tapes that aren't recyclable because of plastic in the adhesives. I learned how even recycled paper often winds up in landfills because of the sorting issues that tape presents. Taking on the challenge of curating and configuring ways of wrapping without tape was one of the hardest things I've had to do, but my sincere effort is a reflection of my gratitude for these activists and for our earth.

# Materials

Wrapping with natural, unbleached kraft paper; recycled paper; and fabric and reusing and repurposing materials are gentle but powerful forms of environmental activism, mindfully protecting our resources in our daily actions. This opportunity pays tribute to the earth and all the gifts it bestows upon us. For basic materials, I keep on hand:

» Roll of natural kraft paper, recycled wrapping paper, washi, and other papers made of natural fibers
» Sheets of 8½" × 11" kraft, recycled, and washi papers and card stock
» Collection of salvaged paper
» Furoshiki and scrap fabric
» 1" brass fasteners
» Twines, threads, buttons, and fabric ribbons

Looking beyond what is considered traditional wrapping paper opens creativity within yourself to see materials around you in a new way. What are the things that call out to you, hold meaning for you or to those who you are wrapping for? Share and showcase the beauty you see in the ordinary materials around you by using them for gifting and wrapping.

I encourage you to find, visit, and support your local creative reuse centers, where materials normally headed for the landfill are redirected into our hands for innovative upcycling and repurposing.

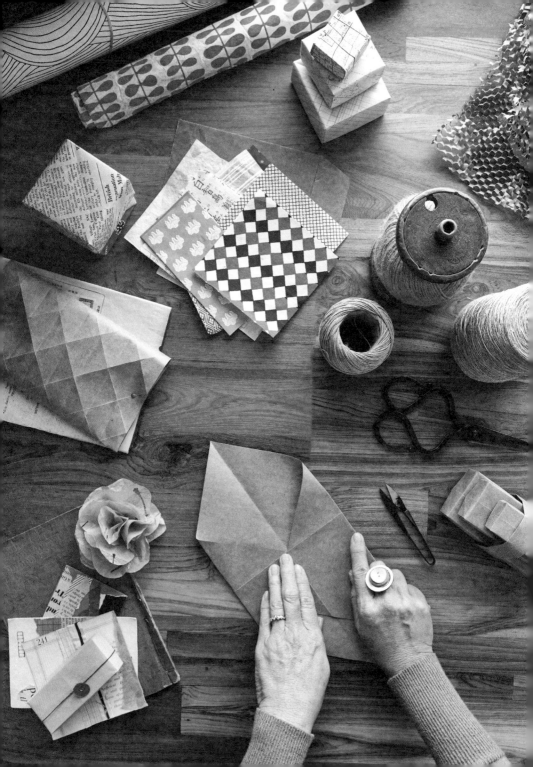

# Space

Creating space to wrap is not only about finding an available area in our physical environment but also about opening ourselves to inspiration.

## EMOTIONAL SPACE

Something we often neglect is creating the emotional space needed to invite feelings of gratitude, though it's a necessary accompaniment to wrapping gratefully. In the quiet hours of twilight before sunrise, listening to the stillness of early morning's silence, I hear the voice of my heart's sound. The ritual of greeting the layer of mist hanging over the clouds, witnessing in awe the glimmer of the sun's light moments before it makes its appearance, has become my way to emotionally prepare for and invite gratitude to my upcoming day. What do you do and where do you go to hear the voice of your heart's sound? I wonder if being attuned to this voice deepens gratitude and changes the way you approach giving and wrapping.

## PHYSICAL SPACE

Dedicated physical space, such as a drawer, box, small desk, or part of a room, also helps to carry out our intentions in a creative way. In the room where I wrap, an antique food basket houses my scrap fabrics. A sculpted lotus flower I purchased from an artist at a flea market carries my brass fasteners. My button collection found a home in a vintage glass jar. Treating utilitarian materials with reverence and care brings me joy as it's a way of showing appreciation for the materials that help me wrap my expressions of gratitude in an artistic way.

*"You get your intuition*
*back when you make space for it."*
—ANNE LAMOTT

# Paper Wrapping Basics

I have designed and compiled the templates in this book to be accessible to beginners, though a few of the wrapping forms might take a little practice. Since many of the wraps start with a square of paper and most call for creases and folds, following are a couple of foundational techniques.

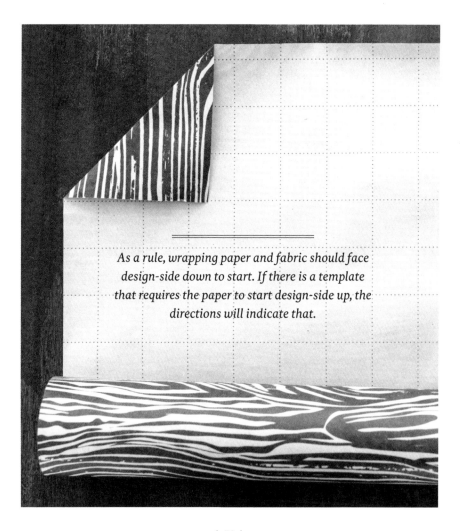

*As a rule, wrapping paper and fabric should face design-side down to start. If there is a template that requires the paper to start design-side up, the directions will indicate that.*

## CUTTING PAPER INTO A SQUARE

To make a square from a rectangular piece of paper, the same principles apply whether you are cutting from an 8½" × 11" sheet or a roll of paper.

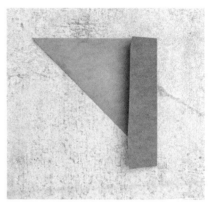

**1.** Create a triangle with the paper by bringing the right corner of the sheet to the paper's left edge. Crease.

**2.** Turn the paper clockwise 90 degrees. Fold the right rectangular portion of the paper to the left, aligning the edges. Crease. Fold back. Make sure the crease line follows the edge of the triangle.

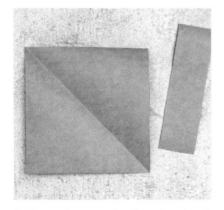

**3.** Flatten the paper. Cut along the edge of the crease of the rectangle piece. You now have a square piece of paper.

*Many of the wrapping designs in this book start with an 8½" × 11" sheet of paper. My hope is that using a size that is so common makes the entry point for experimentation easy.*

## CREASING

Creating lines in the folds of your paper is an integral part of wrapping gifts and creating structural forms. Applying deliberate pressure on the paper serves as a guide to folding and contributes to an aesthetic finish of crisp lines. Your fingers are your most potent tool for creasing.

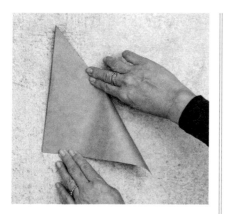

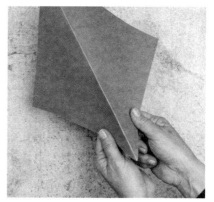

Crease your paper from the center of your fold, taking a finger or thumb outward toward the right and left sides and applying strong pressure.

If you are working with a heavy card stock, creasing the paper in one direction and then re-creasing in the opposite direction will strengthen your folds.

## *Folding with Gratitude*

I value the time I spend creasing and creating folds as a meditative opportunity. As you go about wrapping your gift, making the necessary creases, folding paper, take a moment to center your thoughts and think about the person for whom you are wrapping. Through the deliberate gliding of your hands on the paper, there is potential to enter a quiet mental zone. There is a powerful transfer of energy from heart and hand to paper that takes place in this moment. The paper is the carrier of your message of gratitude to those for whom it was intended.

# Fabric Wrapping Basics

Furoshiki is a Japanese method of wrapping with fabric and also refers to the material itself, a piece of cloth made in many different sizes and used for wrapping a variety of items including gifts. We owe its ingenuity to Japanese forebears who over time thought of different ways to fold, refold, tie, untie, and adjust its shape to fit any item.

You can buy furoshiki, make your own, or simply use scrap fabric. The beauty of utilizing fabric remnants for your wrapping is the ability to cut the fabric to the specifications of your gift. Using pinking shears for cutting gives the fabric a saw-toothed edge that resists fraying.

## FUROSHIKI SIZING

Traditionally, furoshiki was not a square piece of fabric, but was cut with the height slightly longer than the width. In modern times, the availability of wider fabrics, combined with the efficiency of mass-producing square furoshiki, has led to the development and marketing of square versions. For the purposes of wrapping gifts, the square shape works well.

### STANDARD FUROSHIKI SIZES FOR WRAPPING

| | | |
|---|---|---|
| Small | 17" × 17" (45 cm square) | Small boxes, lunch boxes, jars |
| All-Purpose / Basic / Medium | 28" × 28" (70 cm square) | Medium-size boxes |
| Large | 35" × 35" (90 cm square) | Two wine bottles, picnic lunches, transporting food and gifts, large boxes |

## TYING A BASIC FUROSHIKI KNOT

Furoshiki wrapping involves learning to tie and untie a basic knot. This knot serves as the basis for everything you wrap with cloth. The Japanese definition for knot (*musubi* and its verb *musubu*) means "to tie or connect together." The written character, or kanji, of the word itself has layers of meaning suggesting not only holding *things* together but also bringing *people* together.

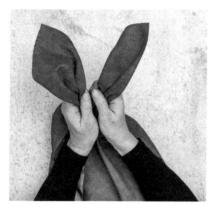

**1.** Hold the two ends of the furoshiki, one in each hand.

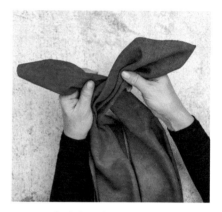

**2.** Cross the left end over the right one.

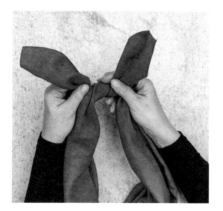

**3.** Pass the length from the left under the length from the right and tighten into a single knot.

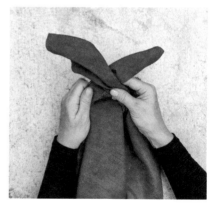

**4.** Cross the length on the right over the length on the left.

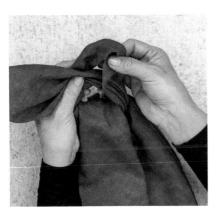

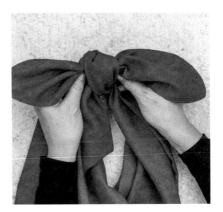

**5.** Pass the length in back over the length on top and pull it through the loop.

**6.** Gently tighten the second half of the knot. The two ends of the fabric should be facing opposite directions parallel to you.

*While tying furoshiki, I remind myself that this knot has meaning beyond its purpose of holding the cloth together. It sets the foundation for connection with people. This reminder changes the wrapping experience for me. Imbued in each knot is a wish, an invitation, a feeling, and an intention of gratitude.*

# The Circulation of Appreciation

Returning gift wrapping to its giver may seem foreign to most people, but in Japanese culture furoshiki is unwrapped during the occasion of its use and brought back home or, if left behind, happily returned to its giver with feelings of gratitude and appreciation.

There is a long-established etiquette of gift giving in Japan called okaeshi. When a gift is received, the social custom is to reciprocate with a small gift in return to show appreciation. I have incorporated the spirit of okaeshi in my life, but in a less structured, nonpressured practice. I acknowledge the gifts I'm given in the form of a thank-you note, a simple gift if the occasion calls for it, even a text message or phone call, but always some kind of tangible action in return.

I see elements of okaeshi in returning the furoshiki to its owner. Friends have returned fabric to me with a thank-you note and sometimes a mini package of cookies or maybe a chocolate bar, the circle of gratitude closing its loop in the act of return and recirculation.

## UNTYING A BASIC FUROSHIKI KNOT

There is an ingenious method for untying furoshiki knots that simplifies the unwrapping experience. As I gently release the knotted fabric, I reflect on the Buddhist approach to life, a journey of mindfully loosening the frustrations, confusions, and aggravations of our internal, metaphorical knots. Wouldn't life be smoother if we took the time to learn how to untie all our knots and share that knowledge with others?

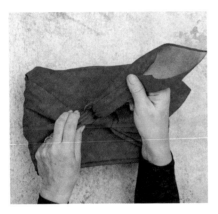

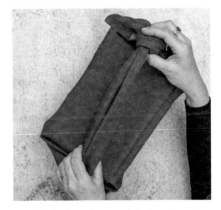

**1.** Grab the end on the left side. Pull up and to the right.

**2.** Hold the knot in your right hand, and the length of fabric on the left in your left hand. Pull your hands apart. The fabric will slide through the knot and untie.

# Creation

Every gift you wrap presents opportunities for creativity that are unique to the recipient, you, your intentions, the relationship between you, the materials available, and the type of gift. Following are step-by-step directions to wrap and embellish gifts of all sizes and shapes, showing how simple design choices can open up limitless imaginative possibilities of expression.

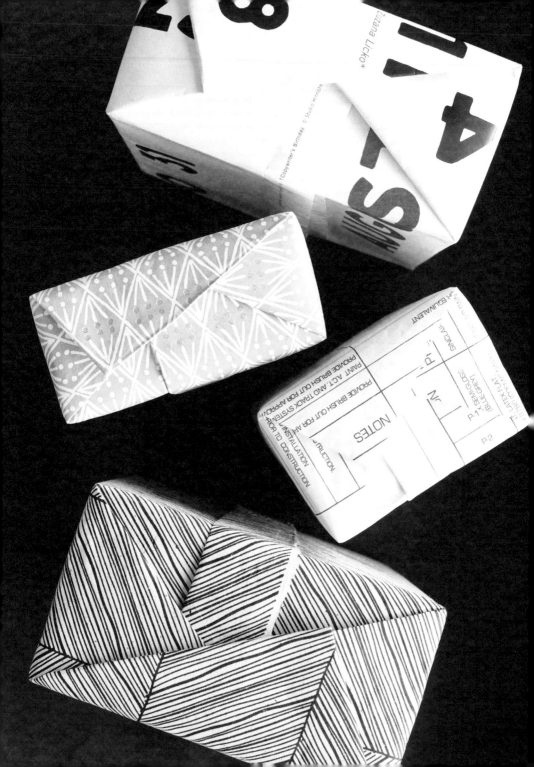

# Wrapping Forms

When you are ready to wrap a gift, explore which wrapping styles suit its shape. The instructions shared here are both practical and creative, inspired by my bicultural influences and traditional Japanese wrapping techniques. I hope they can serve as a basic foundation and springboard for you to create something unique. I encourage you to trust your artistic intuition.

# Embellishments

I consider embellishments on a gift as another opportunity for artistic expression of an intention. Try altering the surface of the wrapping paper with pleating, tearing, or crumpling, or you could add other enhancements, such as bands, bows, flowers, hearts, and gift tags.

# Basic Box Wrap

I've been obsessed for some time with finding a way to replace the standard wrapping style with a method that needs no tape. How to secure the sides of the box wrap with only a fold was a particular challenge. In exploring Japanese wrapping styles, I came upon a fold technique that I adapted and share with you here.

This design is suitable for both square and rectangular boxes that are at least 2½" deep. For shallower boxes, see the Book or Shallow Box Wrap on page 76.

## WHAT YOU NEED
- A sheet of paper to fit the gift
- Scissors
- Ruler

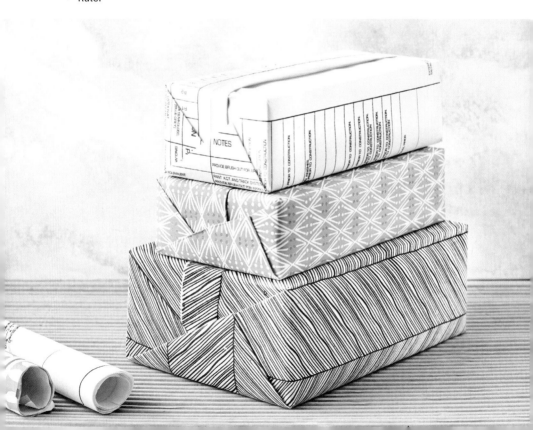

## HOW TO MEASURE PAPER FIT

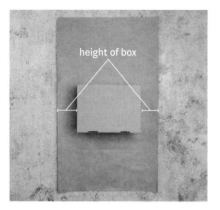

**Width of box:** The paper should come close to the top edge on both the left and right sides of the box without going over the edge.

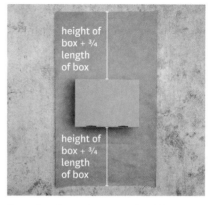

**Length of box:** The paper should wrap three-quarters of the way around the top of the box in both directions.

## HOW TO WRAP

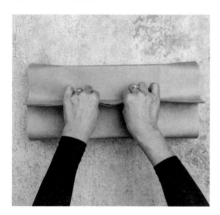

**1.** Center your box top-down on the paper. Pull the top and bottom edges of the paper taut, meeting in the center.

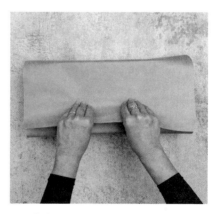

**2.** Pull the paper toward you along the full width.

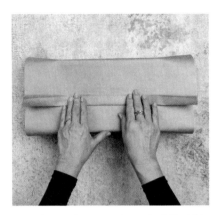

**3.** Fold away from you along the full width, with the edges of the paper meeting the center line.

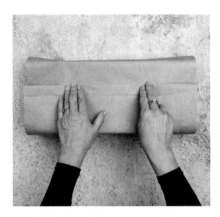

**4.** Fold the band that you created away from you again, crossing the center line.

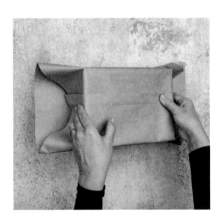

**5.** Check that there is an equal amount of paper on both the left and right sides and press the paper downward. The paper should almost cover the sides of the box without going over.

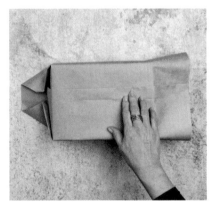

**6.** Create temporary folds on one side to hold the paper in place, then stand the box on its end.

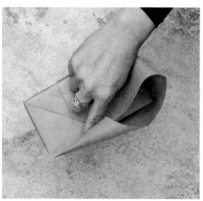

**7.** Orient the box so the band you created in previous steps is facing away from you, as shown. Push the paper at the top left corner inward, pressing in a fold that aligns with the edge of the box. This fold creates a triangular flap. Press the triangular flap against the side of the box.

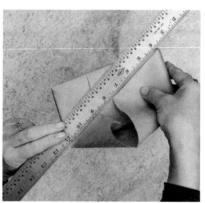

**8.** At the right side, don't push the paper all the way to the vertical edge of the box as you did on the left side. Use a ruler to find the angle that connects the bottom left and top right corners. While keeping the paper taut along the vertical side of the box, fold the right flap to align with that angle.

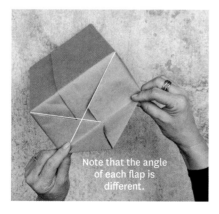

Note that the angle of each flap is different.

**9.** Press creases into the bottom flap and fold up.

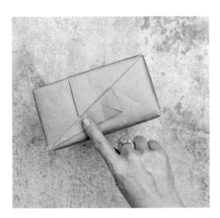

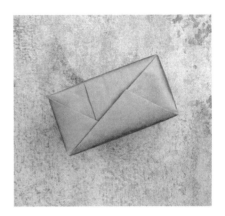

**10.** Fold the top of the flap back at an angle that aligns with the corner-to-corner diagonal. Run a fingernail along the fold to strengthen the crease.

**11.** Reverse the direction of the fold, tucking the flap inside to secure the end.

**12.** Repeat steps 7–11 on the other side of the box.

# Variation with Pocket

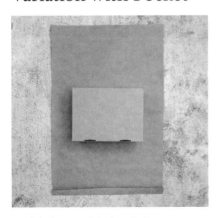

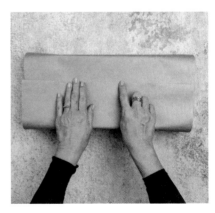

**1.** With the top of the box facing up, center it on the paper, oriented horizontally. Fold the bottom edge of the paper up approximately 1".

**2.** Fold the top of the paper over the box and wrap the folded edge at the bottom over that.

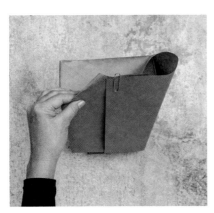

**3.** Go to step 5 of the Basic Box Wrap, but have the seam at the top of the box instead of the bottom and press the paper upward rather than downward, so that the pocket ends up on top. (*Tip*: Temporarily holding the seam closed with a paper clip can be helpful.) Continue with the rest of the steps for the Basic Box Wrap.

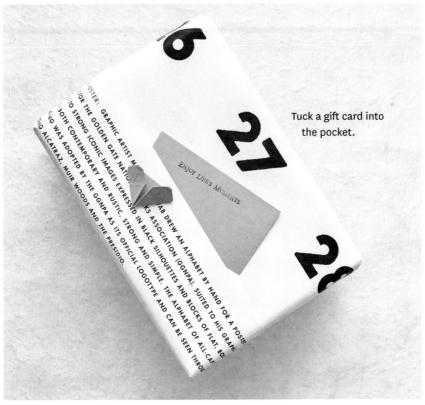

Tuck a gift card into the pocket.

# Book or Shallow Box Wrap

I originally designed this style as a wrap for books and shallow boxes, but it works equally well for all box sizes, square and rectangular. It has become my all-around favorite tapeless wrapping method. I'm particularly fond of how it easily unwraps—like an unveiling—giving books, especially, a pleasurable reveal. Books are one of my favorite things to give and to wrap; I feel grateful to the authors who share their stories, creative skills, and perspectives, which I can then gift to others.

**WHAT YOU NEED**
- A sheet of paper to fit the gift
- Scissors

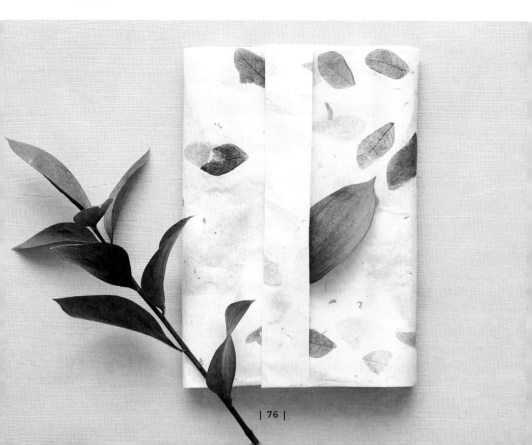

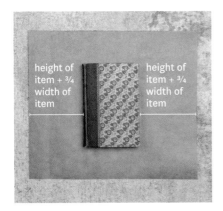

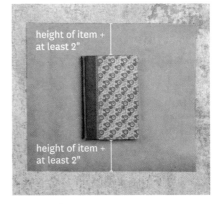

**Width of item:** The paper should wrap over the top of the book or box and cover approximately three-quarters of the item in each direction, once from the left side and once from the right.

**Length of item:** The paper should wrap at least 2" over the top and bottom of the book or box.

HOW TO WRAP

**1.** With the design side of the paper facing up (if your paper has a design), fold the right edge approximately ½" along the full length of the paper. Repeat to create a double fold.

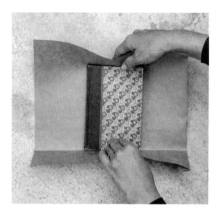

**2.** Turn the paper over so that the double fold is facedown on the right side. Mark or crease the point at which the paper folds around the top and base of the book or box.

**3.** Using these marks, strongly crease the top and bottom of the paper to match the length of the item. Place the item inside the top and bottom flaps, aligning it to fit within the crease lines. Turn the package so the left side is on top.

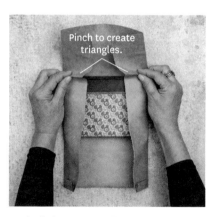

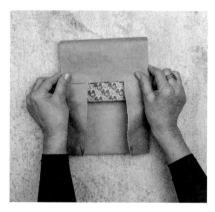

**4.** Pinch the paper at the top corners of the item at an angle, creating triangle shapes. The top flap will lift slightly, guiding you to the next step.

**5.** Fold the flap over the item and then repeat step 4 on the opposite side.

**6.** Insert the unfolded flap into the folded flap. Sharpen the creases at all edges for a clean, finished look.

## Variations

Step 1 offers room for a lot of creative variation. The downward vertical fold is what will be visible on the front of the package. Try:

» Tearing the paper's edge (see page 151)
» Pleating the edge (note that you need to add width to the paper if pleating; see page 143)
» Shaping the edge with scalloped, serrated, or other craft scissors

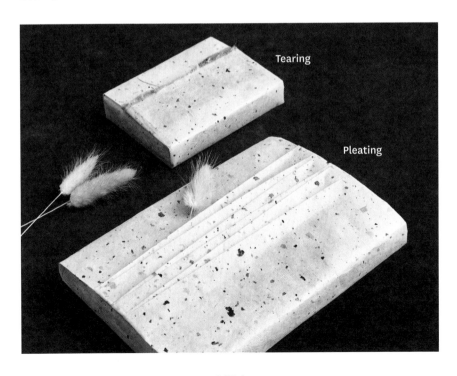

Tearing

Pleating

# Square and Cube Box Wrap

I did not attempt to figure out this wrap for a long time. Defying any principles we associate with wrapping and how folds come together on a box, this wrap is like a maze. When the folds all line up in a diagonal, it feels miraculous. I love how in the end there is an opening to tuck in a flower, a note, or any personalized embellishment. I've seen variations of this wrapping style in Japan but could never find anything like it in the US. I'm happy to share with you a version that finally worked for me.

**WHAT YOU NEED**
- A sheet of paper to fit the gift
- Scissors

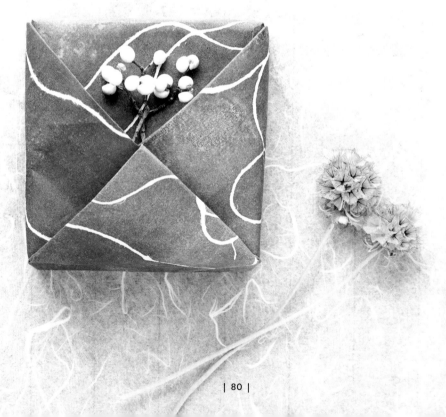

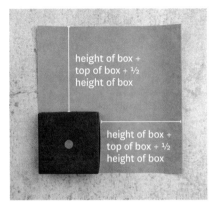

height of box + top of box + ½ height of box

height of box + top of box + ½ height of box

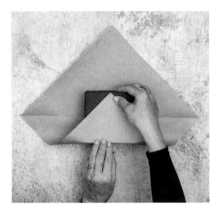

With the box aligned in one corner of the paper, the paper should cover the bottom, one side, the top, and half of the next side. Cut the paper into a square.

**1.** Orient the paper in a diamond shape and center the box on top. Wrap the bottom flap of paper over the top of the box, aligning the point with the middle of the top edge of the box. Hold that flap taut with one hand as you move to the next step.

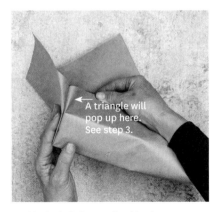

A triangle will pop up here. See step 3.

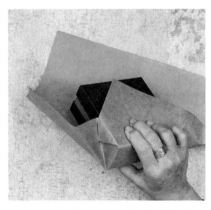

**2.** Lift the left flap and guide the paper to align with the side of the box.

**3.** As you are lifting, a small triangle will pop up. Crease and fold that to the left, in between the flap and the box.

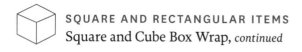

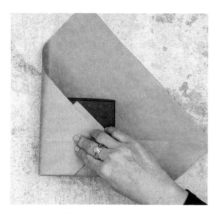

**4.** Fold the left flap over the top of the box, aligning the edges.

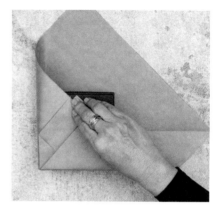

**5.** Fold the bottom edge of the flap back, aligning with the left edge of the box.

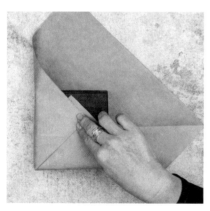

**6.** Reverse the direction of the fold, turning the bottom edge of the flap under.

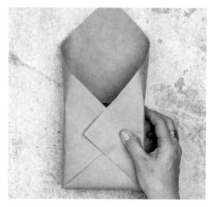

**7.** Repeat steps 2–6 on the right side. The right flap should overlap the left.

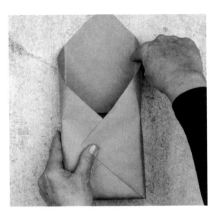

**8.** Make creases along the top flap using your fingernail.

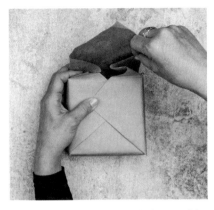

**9.** At the top of the box, push the two sides inward and crease, which will bring the top flap forward. Wrap the top flap over the top of the box and crease in place.

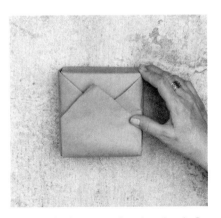

**10.** Turn the box around so the triangle flap is pointing toward the top.

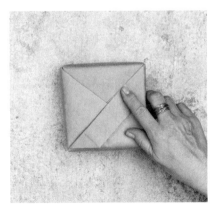

**11.** Fold the left edge of the triangle so the crease aligns with the diagonal of the right flap underneath. (*Tip:* A ruler can be helpful here to guide the fold.)

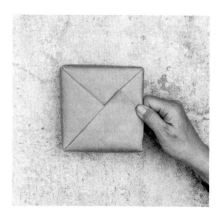

**12.** Reverse the direction of the crease, folding the flap inward.

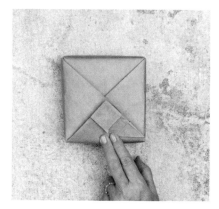

**13.** Fold the right edge of the top flap to the left, aligning with the diagonal of the left flap underneath.

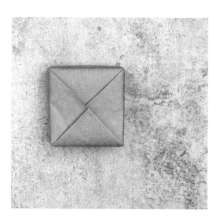

**14.** Reverse the direction of the fold and tuck the top flap inside to secure the wrap.

## Expressing Your Intentions

I gravitate toward wrapping styles in which a fold or a pocket holds a card, note, or gift tag—an opportunity to overtly express feelings of gratitude. We may wrap gifts with intention and symbolically express good wishes in each fold, but the one who receives that gift might miss our silent message. The wrapping might be quickly torn apart and thrown aside with the objective to get to what's inside. As in the words of writer Gertrude Stein, "Silent gratitude isn't very much to anyone."

*"Feeling gratitude and not expressing it is like
wrapping a present and not giving it."*
—WILLIAM ARTHUR WARD

# Furoshiki Basic Box Wrap

I use this traditional technique not only to wrap presents, with the furoshiki as part of the gift, but also to package and deliver boxed homemade meals as a nurturing and uplifting way to say "get well soon." The fabric wrapping, after assisting in the meal's transport and delighting the recipient, is intended to be returned to me so that its joyful purpose can continue to be recirculated.

This design is suitable for both square and rectangular boxes.

## WHAT YOU NEED

- Furoshiki or scrap fabric to fit the gift

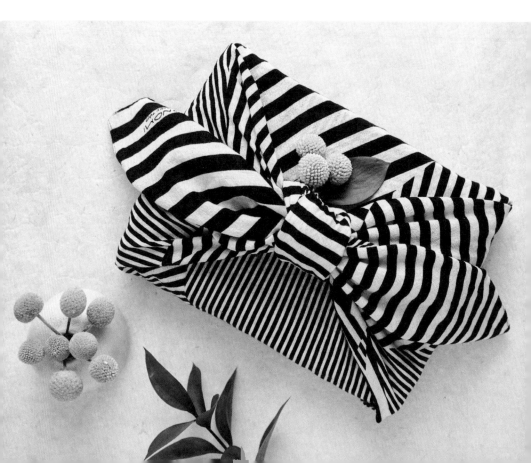

opposite side
of fabric

design side of
fabric

**1.** Lay the furoshiki flat, design-side down, oriented in a diamond shape. Center the box on top. Keeping the box in the same position, fold the bottom point of the cloth over the box, tucking any excess fabric under the box. Pull taut.

**2.** Fold the upper point of the cloth over the box and pull taut. Excess fabric can also be folded under.

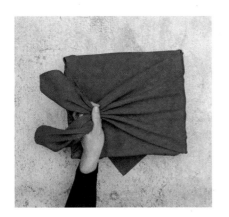

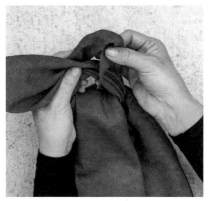

**3.** Tuck in the fabric at the corners and wrap the sides of the fabric over the top of the box.

**4.** Follow the steps for Tying a Basic Furoshiki Knot on page 62.

# Furoshiki Square Box Wrap

I'm a fan of this design because of its dynamic sculptural potential. The corners of the fabric can tuck into the center to form a flower, stand dramatically upward, or flare out like a display of fireworks. Enjoy experimenting with all the possibilities!

## WHAT YOU NEED

- Furoshiki or scrap fabric to fit the gift

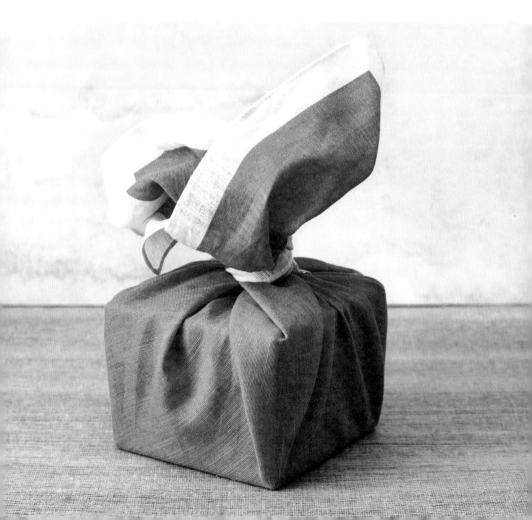

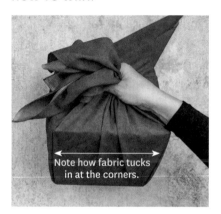

Note how fabric tucks
in at the corners.

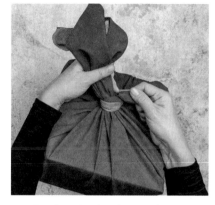

**1.** Lay the furoshiki flat, oriented in a diamond shape, and center the box on top. Gather the bottom and side corners together, tucking the corners inward, and cinch the fabric tightly in one hand against the lid of the box.

**2.** Using the other hand, wrap the remaining corner of the fabric around the cinched bundle and secure with a single knot.

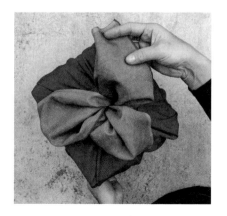

**3.** Shape and tuck the fabric tips into any design you desire.

# Origami Square Box

If you are going to master one origami design in the world of wrapping, I would recommend this one (and the rectangular box that follows). It is a classic design invented centuries ago that can be used in a multitude of ways. Made with paper you personally select, the box alone can express your intentions and become the gift.

The finished box is approximately 3" × 3" × 1½". Starting with smaller or larger sheets of paper, you can fold this design to fit any gift. I recommend card stock paper for heavier objects.

**WHAT YOU NEED**

- Two 8½" × 8½" sheets of paper

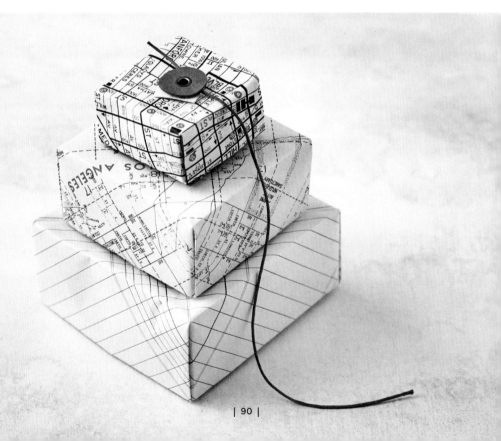

**1.** Fold one sheet of paper in half in both directions and unfold so you have four squares marked with creases.

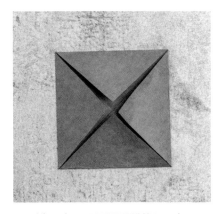

**2.** Fold each corner toward the center, creasing to create four triangles.

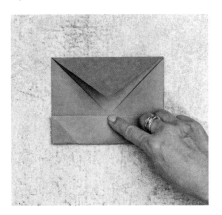

**3.** Fold the bottom edge to the center line and unfold to create a crease line. Repeat on all sides.

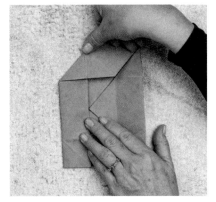

**4.** Unfold the top triangle. Fold the left edge to center. Fold the top left corner at a diagonal using the existing crease. Apply strong pressure to reinforce the crease. Unfold until the paper looks like it did in step 2. Repeat step 4 folds on all sides.

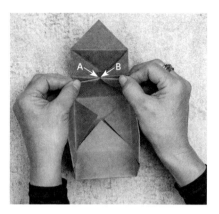

**5.** Unfold the top triangle. Using the existing creases as guides, bring points A and B together. Press the folds in place.

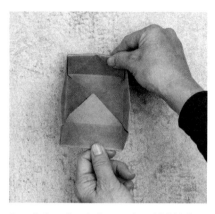

**6.** Pull the triangle forward and fold it into the box toward the center.

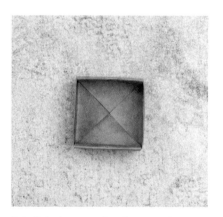

**7.** Pull the bottom triangle out and repeat steps 5 and 6 to finish the box tray.

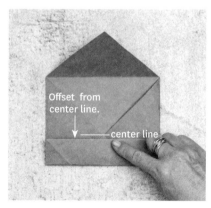

**8.** To create the box lid from the second sheet of paper, repeat steps 1–7 with one change to step 3. Fold the edges to a point slightly offset from the center line, which allows for the lid to fit over the tray.

# Origami Rectangular Box

The finished box is approximately 5½" × 2½" × 1". By using smaller or larger sheets of paper, you can fold this design to fit any gift.

If you find yourself overwhelmed by the lengthy instructions, don't despair. Take one step at a time. Trust each step. Every fold and crease will guide you to your desired destination. In the end, you will be in awe of what you were able to create from two sheets of square paper.

## WHAT YOU NEED
- Two 8½" × 8½" sheets of paper

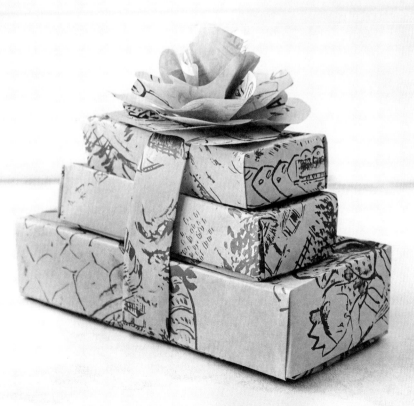

HOW TO WRAP

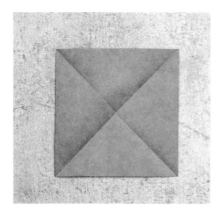

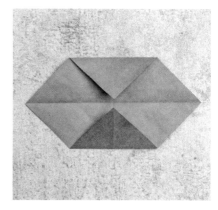

**1.** Fold one sheet of paper into a triangle and unfold. Fold the opposite corners together to create another triangle and unfold. You should have an X in the center of the paper.

**2.** Rotate paper 45°. Fold one corner to the middle and crease. Repeat on the opposite side. Unfold.

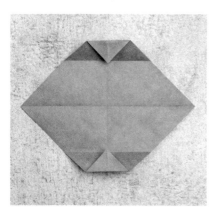

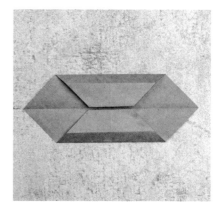

**3.** Bring one corner to the closest crease line created by the previous fold and crease again. Repeat on the opposite side.

**4.** Bring the top and bottom folded triangle flaps to the center line and crease.

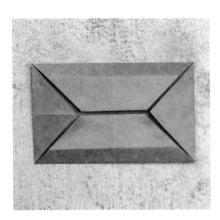

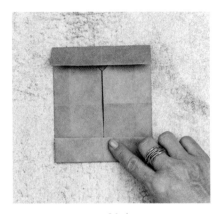

**5.** Fold the side triangles inward to meet the flaps. The piece is now rectangular.

**6.** Rotate the paper 90 degrees and fold the bottom edge to the point where the side flaps and triangle point meet. Repeat on the opposite side, flattening and creasing.

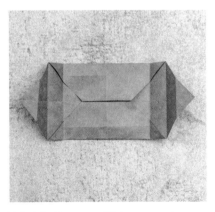

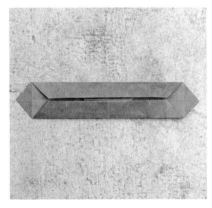

**7.** Rotate the paper 90 degrees and open the two side flaps.

**8.** Fold the bottom edge of the paper to the center line and crease. Repeat on the opposite side.

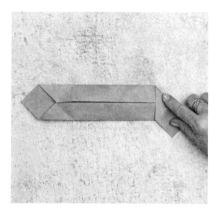

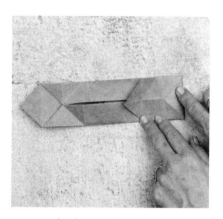

**9.** Fold the top right corner at a diagonal to the third crease line from the edge. Unfold. Repeat on all corners. These folds help in shaping the box.

**10.** Note the three vertical creases on either end. Re-crease these strongly, using a fingernail or bone folder.

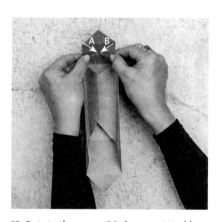

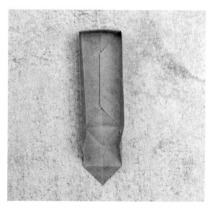

**11.** Rotate the paper 90 degrees. Working from the top, open the folds and bring points A and B together. With your thumbs, press along the inside creases. You should see the shape of the box emerging.

**12.** Take the upper flap and fold it into the box. Repeat on the other side. You've completed the tray of the box.

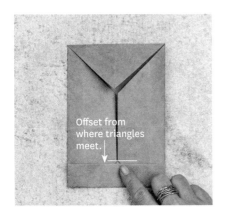

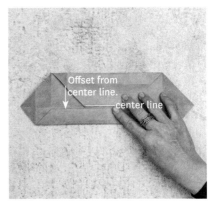

**13.** To make the lid, use the other sheet of paper and repeat steps 1–5. At step 6, fold the paper to a point slightly before where the triangle corners meet, then continue with step 7. At step 8, fold the paper to a point slightly offset from the center line for both the top and bottom. Repeat steps 9–12 to finish the lid.

# Modern Folds Cube Box

Origami projects are often made with square paper but this one is made from an 8½" × 11" sheet, which makes it even easier to bring to life. There is a moment in the process when the paper stands up to take the shape of the box. It feels like magic each time!

The finished box is approximately 3" × 3" × 3". Starting with smaller or larger sheets of paper, you can fold this design to fit any gift. Using different papers for the box and lid creates a dramatic and artistic effect.

## WHAT YOU NEED

- 8½" × 11" sheet of paper
- 8½" × 8½" sheet of paper

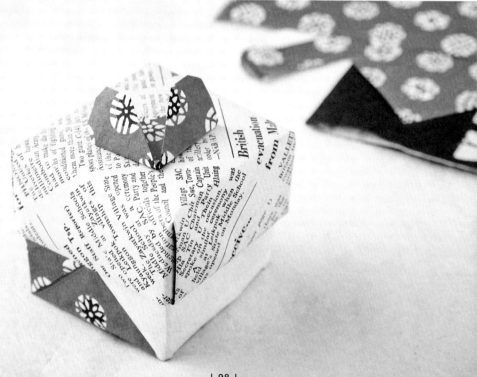

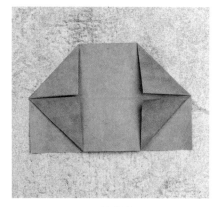

**1.** Orient the larger sheet of paper vertically and fold it in half, bringing the bottom edge to the top. Flip the paper over so the folded crease is on top. Fold in half again, bringing the bottom paper upward.

**2.** Open the second fold from step 1. Fold the top layer of the bottom left and right corners diagonally to the center crease. Fold the top left and right corners diagonally to the center crease.

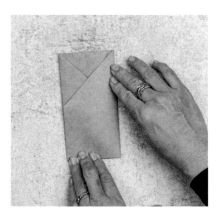

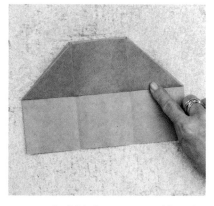

**3.** Using the bases of the triangles as your guide for placement of the crease, fold the left side inward. Repeat on the right side.

**4.** Open the folds from step 3. Fold up the top layer of the bottom section along the center line.

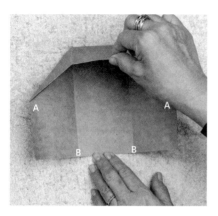

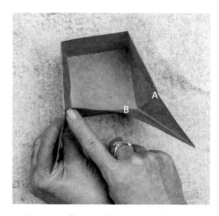

**5.** Lift the middle crease. You should start to see the shape of the box. Square up the corners. (Note locations of points A and B for the next step.)

**6.** Create a diagonal (by connecting points A and B, matching up the diagonal lines and creating two triangles in outward directions).

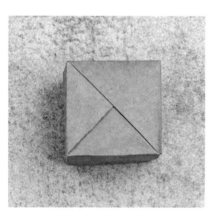

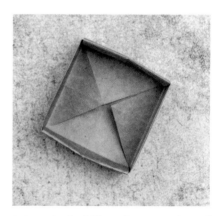

**7.** Fold each triangle shape against the side of the box, tucking the points behind the existing folds.

**8.** To make the lid from the square sheet of paper, follow the directions for the *base*—not the lid—of the Origami Square Box on page 91. The base fits snugly as a lid for this design.

# Modern Folds Rectangular Box

I have found this design to be the perfect size and shape for packaging an assortment of baked goods, but it can easily be used for anything needing a box. There is something reassuring about knowing that whenever I have the unexpected urge to give a homemade gift, I can fold paper into sections, making deep creases in the right places, and a nice rectangular structure will emerge to package my intentions. This box has become my savior and go-to wrapping solution, and hopefully it will become yours.

The finished box is approximately 4¼" × 5½" × 2⅛". Starting with smaller or larger sheets of paper, you can fold this design to fit any gift.

**WHAT YOU NEED**
- Two 8½" × 11" sheets of paper

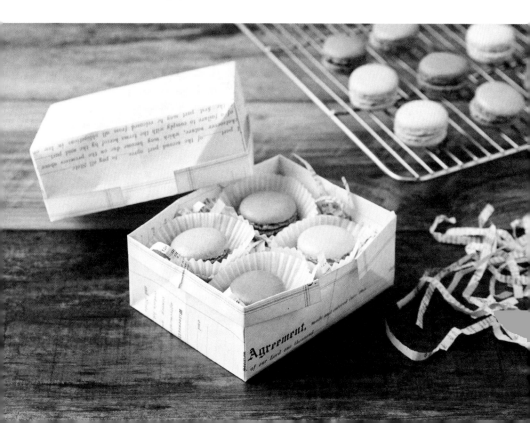

HOW TO WRAP

**1.** Orient the paper horizontally. Fold it in half and unfold. Then fold both the top and bottom edges to the center crease. Unfold.

**2.** Turn the paper to a vertical orientation. Fold it in half and unfold. Then fold both the top and bottom edges to the center crease.

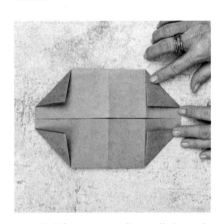

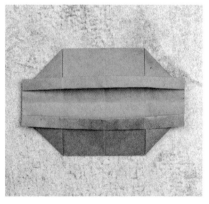

**3.** Fold all four corners diagonally inward to meet the closest crease line. Use a fingernail to make strong creases, which are necessary here for clean box edges.

**4.** Fold the top layer of paper away from the center, aligning each fold with the edges of the triangles.

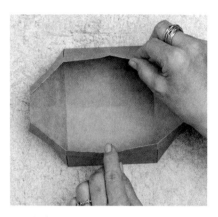

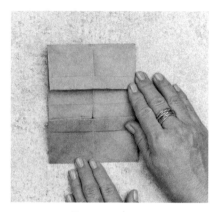

**5.** Pull the long edges up and away from each other, opening the folded structure.

**6.** Push the other two edges inward to collapse the box.

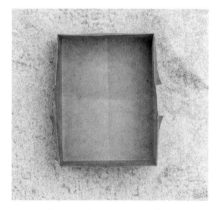

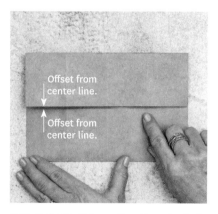

Offset from center line.

Offset from center line.

**7.** Once flattened, strengthen all creases. Open the box and adjust the shape and creases to right angles.

**8.** To make the lid, use the other sheet of paper and follow the same steps with one change. In step 2, fold the paper to a point slightly offset from the center line for both the top and bottom.

# Furoshiki Money Wrap

This design is a traditional furoshiki wrapping method for celebratory, festive occasions. Monetary gifts in Japan are wrapped in folded paper or placed in envelopes and oftentimes wrapped again in furoshiki. The giver customarily unfolds and removes the furoshiki as the gift is given. The fabric wrapping serves as a respectful and considerate way to transport and present the gift but is not intended to be part of the gift. Since you may want the recipient to keep the fabric, I've added an additional step to the traditional design, tucking the final fold into the side opening to create a finished look.

Traditional furoshiki often have surface patterns that signify different meanings. Wrapping monetary gifts with thoughtfully selected furoshiki or fabric is a lovely way to imbue your gift with another layer of intention.

## WHAT YOU NEED
- Small furoshiki or scrap fabric

**1.** Lay the furoshiki flat, oriented in a diamond shape. Place the gift envelope on the fabric vertically, slightly to the left of center.

**2.** Bring the left side over to cover the envelope and tuck under the extra fabric.

**3.** Bring the top side over, then the bottom side, tucking any extra fabric between the layers.

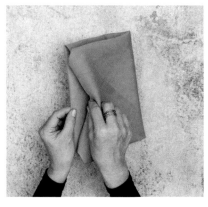

**4.** Bring the right side over, tucking the extra fabric inside the folds.

# Layered with Love Envelope

In many Asian cultures, money given to others is wrapped or put into an envelope, transforming an impersonal transaction to one that is an expression of care and gratitude. Based on a traditional Japanese technique, I altered the original vertical design to fit the horizontal orientation and shape of gift cards.

The finished envelope is approximately 4½" × 3". Starting with a smaller or larger sheet of paper, you can fold this envelope design to fit any flat item you want to wrap. As a variation, try using paper with different designs on each side, which creates a layered look with nice contrast.

## WHAT YOU NEED

- 8½" × 8½" sheet of paper

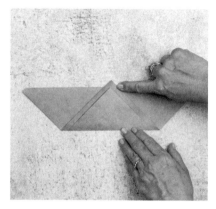

**1.** With the paper oriented in a diamond shape, fold up the bottom edge into a triangle, offsetting the edges. Insert the gift between the layers.

**2.** Turn the paper over, so the triangle is facing down. Fold the points of the triangle toward the top, aligning the interior triangle tip with the horizontal edge.

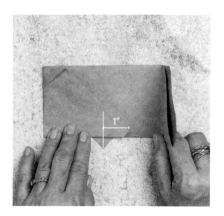

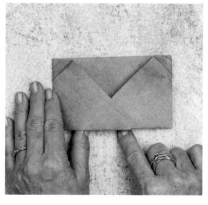

**3.** Turn the paper over with the triangle facing down. Using the tip of the triangle as your center point, fold one wing approximately 1" past that center.

**4.** Repeat on the other side, tucking one wing into the fold of the other to secure the envelope. Tuck the triangle tip at the bottom in between the layers.

# Dreams-Come-True Pocket Envelope

I designed this envelope with the folds in the back interlocking, facing upward to contain and hold our deepest wishes for those we love and appreciate. The application fee for college, a gift certificate for a writing or yoga class, or even just a heartfelt letter of encouragement can be wrapped in this envelope, reflecting your hopes and intentions that the recipient's dreams come true. You can tuck a small tag or notecard into the front pocket.

The finished wrap is approximately 4" × 5½". Starting with a smaller or larger sheet of paper, you can fold this envelope design to fit any flat item you want to wrap.

### WHAT YOU NEED
- 8½" × 11" sheet of paper

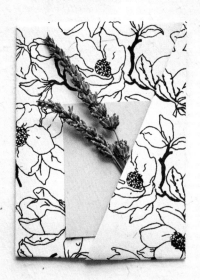
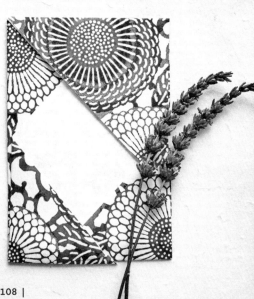

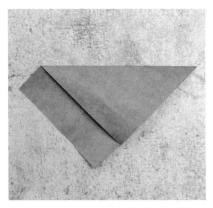

**1.** With the paper oriented horizontally, fold the top right corner to the bottom edge, creating a triangle. Turn the paper 45 degrees counterclockwise so that the folded edge is horizontally oriented.

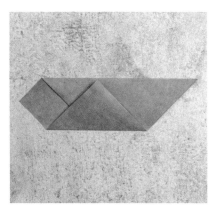

**2.** Fold the bottom corner to the top edge.

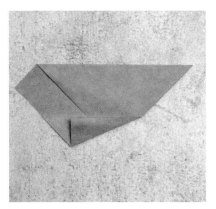

**3.** Unfold the last crease. Bring the bottom right edge to meet that crease line and fold.

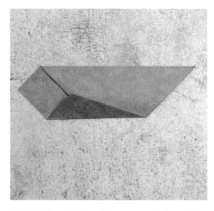

**4.** Fold the bottom flap upward along the existing crease.

## Dreams-Come-True Pocket Envelope, *continued*

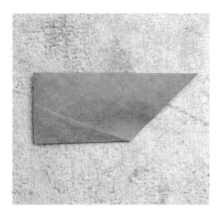

**5.** Fold the left edge under, creating a vertical crease and aligning the fold with the peak of the bottom-flap triangle.

**6.** Fold the right edge under, creating a vertical crease and aligning the fold with the bottom triangle's right corner.

**7.** Turn the piece over and insert the triangle flap folded under in step 6 into the pocket created by the opposing edge. Open the wrap to insert your item and refold. Slip a note into the pocket on the front.

# Pinwheel Pouch

This pouch is a traditional origami design, usually folded with standard lightweight paper. I like to use a heavier paper, which causes the interlocking wings to flare out more dramatically like a three-dimensional sculpture or pinwheel. There is something so intriguing and striking about it as gift wrap: It's worthy of presenting on a tray. Suitable for a heartfelt note, jewelry, or other flat item, this wrap makes any gift feel like a special offering, reflecting your appreciation and love.

The finished pouch is 4½" square. Starting with a smaller or larger sheet of paper, you can fold this design to any size you want.

## WHAT YOU NEED
- 8½" × 8½" sheet of paper

HOW TO WRAP

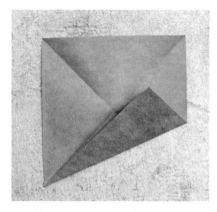

**1.** Fold the paper into a triangle and unfold. Fold the opposite corners together to create another triangle and unfold. You should have an X in the center of the paper.

**2.** With the paper oriented as a square, fold the bottom edge to meet the diagonal center line.

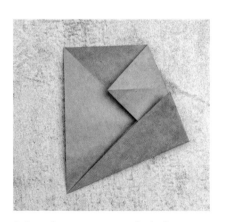

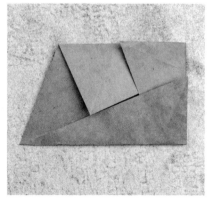

**3.** Turn the paper counterclockwise 90 degrees and fold the right corner to the diagonal center line again.

**4.** Repeat step 3.

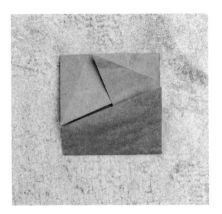

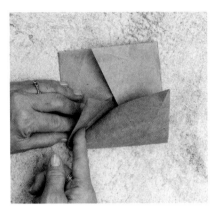

**5.** Turn the paper counterclockwise 90 degrees a third time and fold the bottom edge to align with the diagonal center again.

**6.** Open the last fold. Lift the bottom left flap and refold the bottom toward the center again, gently inserting it under the left flap.

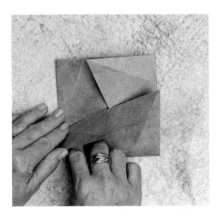

**7.** Use your finger to push the paper flat against the left edge, folding the crease in the bottom left flap in reverse direction.

# Obi Wrap

Just as a Japanese kimono is secured with a sash called an obi, this wrap has a built-in band that not only fastens the package without tape but also creates a pocket for embellishments. Whenever I wrap a soft item using this method, it reminds me of how in small boutiques especially, clothing purchases are commonly wrapped in tissue, the layers of paper covering the garment on both sides before it's tucked inside a shopping bag to be brought home. The instructions that follow mirror this loose way of wrapping, allowing soft gifts room to breathe, safely tucked within the folds.

For wrapping soft items, I encourage you to use flexibly textured materials like crumpled or thin-textured washi paper, which molds itself to the shape of the gift.

### WHAT YOU NEED
- A sheet of flat or crumpled paper to fit the gift (see page 153 for instructions on crumpling)
- Wrapping tissue
- Scissors

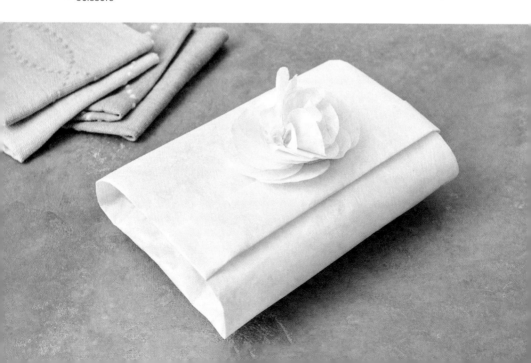

## HOW TO MEASURE PAPER FIT

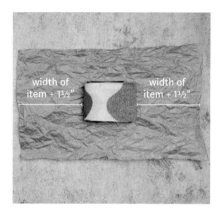

width of item + 1½"    width of item + 1½"

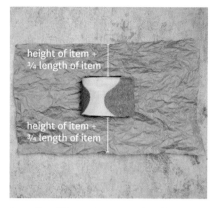

height of item + ¾ length of item

height of item + ¾ length of item

**Width of item:** The paper should completely wrap around the item, fully overlapping the top side. Add 3" for the band.

**Length of item:** The paper should wrap to the top of the item and cover approximately three-quarters of the item twice, once on the top side and once on the bottom. Perfect measurements are not necessary.

## HOW TO WRAP

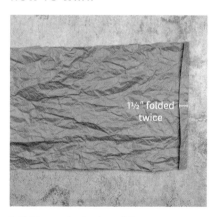

1½" folded twice

**1.** Fold one short edge of the paper approximately 1½" and then fold again to create a band. Turn the paper over, with the band facing down.

**2.** Place the soft item in the center of the paper. (Note: Wrap the soft item in tissue first, if desired.)

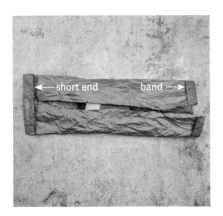

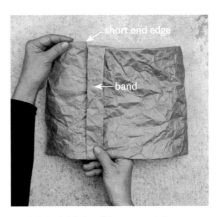

**3.** Cover the item by bringing the bottom edge up and the upper edge down. Crease gently along the top and bottom enough to hold the paper in place. Fold the short end that is opposite the band approximately 1½".

**4.** Lightly fold the sides toward the center. To secure and finish the wrapping, tuck the short end inside the band end as far as it will go. Gently push the sides down to hold the paper in place.

# Variations

Step 1 offers room for a lot of creative variation. The band is what will be visible on the front of the package. In lieu of the band, try:

» Tearing the paper's edge (see page 151)
» Pleating the edge (note that you need to add width to the paper if pleating; see page 143)
» Shaping the edge with scalloped, serrated, or other craft scissors
» Adding strips of paper to create layers

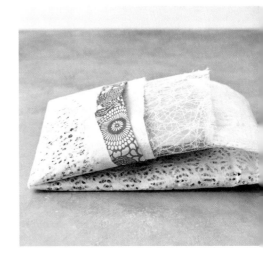

# Envelope Wrap

This design is a scaled-up version of a traditional origami envelope. I was inspired by artist Ruth Asawa, who patiently encouraged my appreciation for origami by just sitting with me and folding. Her large-scale origami sculptures continue to capture my imagination.

The finished envelope is approximately 12½" × 7". Starting with a smaller or larger sheet of paper, you can fold this design to fit any soft item you want to wrap. This is a good opportunity to upcycle larger-sized papers like maps, old architectural renderings, or newspaper.

## WHAT YOU NEED

- 20" × 20" sheet of paper
- Scissors

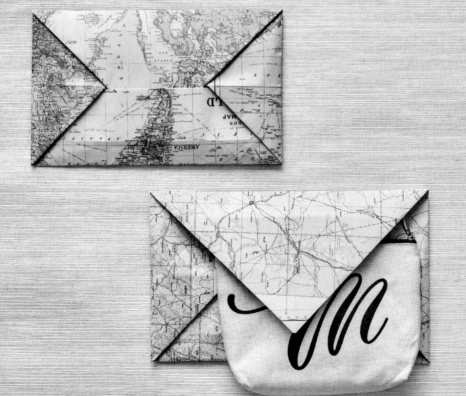

HOW TO WRAP

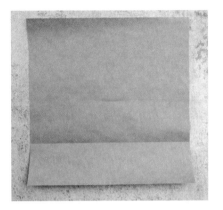

**1.** Pinch the paper in the middle to mark the vertical center line. Fold the bottom edge of the paper to the center line. Unfold.

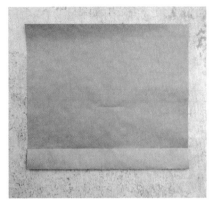

**2.** Fold the bottom edge of the paper to the crease made in step 1.

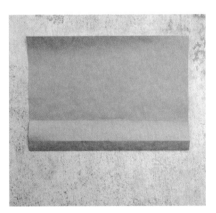

**3.** Bring the folded bottom edge to the center line and crease.

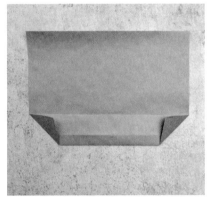

**4.** Fold the bottom left corner into a triangle, bringing the outside edge to the edge of the folded band. Repeat on the bottom right.

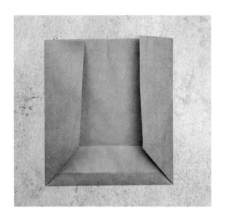

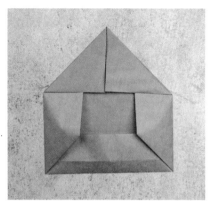

**5.** Using the inside edge of each triangle as a guide, fold the left and right sides toward the middle. Pinch the paper at the top to mark the horizontal center.

**6.** Fold the two top corners so their edges meet at the center.

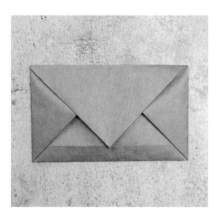

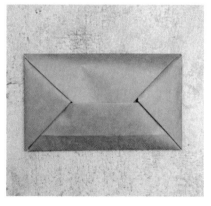

**7.** Using the bottom edge of the two triangles you created in step 6 as a guide, fold the top down to create the envelope flap.

**8.** Gently open the package and place your item inside. Putting a board into the envelope will create a rigid structure, if desired. Close up by slipping the tip of the flap into the envelope opening.

# Basic Wine Bottle Wrap

Some discoveries are extremely joyful. The day I was able to wrap a wine bottle using an 8½" × 11" sheet of paper was such a moment. The ease and simplicity of this method is enough reason for delight, but what I love most is how this wrap serves as the ideal canvas for creatively expressing sentiments. Words of appreciation can be written on the paper and wrapped around the bottle, a seasonal touch of greenery tucked in the band. The possibilities are endless, customizing to the person and the occasion.

The following directions mirror the Basic Band (page 154), but I've calculated the measurements to fit a standard wine bottle.

### WHAT YOU NEED
· 8½" × 11" sheet of paper

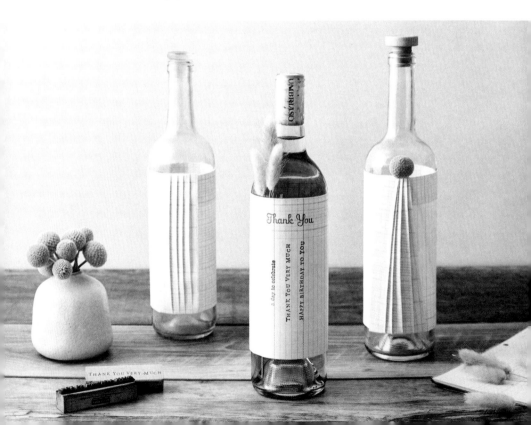

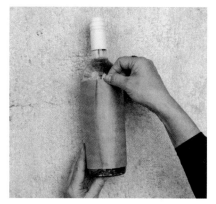

**1.** Lay the paper down in a landscape orientation. Fold the bottom edge up approximately 1". Repeat on the top edge.

**2.** Wrap the band around the bottle, inserting one end of the paper into the folds of the opposite end, adjusting the fit until the paper is secure.

# Variations

» Add an additional Basic Band on top of the wine wrap.

» Tuck seasonal elements from nature into a second band.

» Add horizontal pleating (see page 143).

» Use a flat, rather than dimensional, version of the Akari Bottle Wrap (page 122).

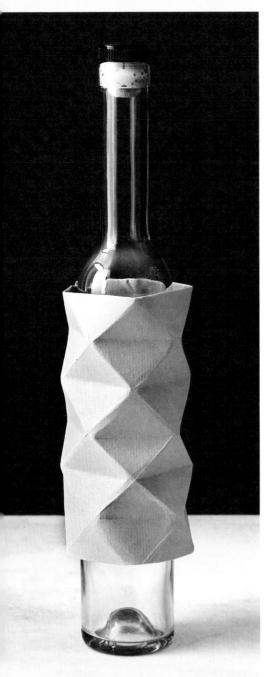

# Akari Bottle Wrap

I see wrapping as something that can light up a gift. It carries energy like the sun, allowing the moon to glow. The Japanese word for light is *akari*. When I think of akari, I think of the Obon festival held in Japan in August, when people travel back to their hometowns, spending time with families and remembering their ancestors and loved ones who have passed. Lanterns are lit around the country so the spirits of loved ones can find their way back. Inspired by these lanterns and the feeling of the festival, I reconfigured the traditional origami lantern into a band for wrapping, which is sure to light up the person receiving your gift.

The finished band is suitable for bottles with a circumference of up to 8", such as many artisanal olive oils and vinegars. To fit a standard wine bottle, start with a sheet of paper that is proportionally larger.

*Tip:* At every step, the creases should align, helping to guide your folds precisely. The precision of the geometry is important.

## WHAT YOU NEED

- 8½" × 11" sheet of paper

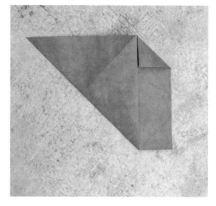

**1.** Lay the paper down in a landscape orientation. Fold the upper left corner to meet the bottom edge, creating a triangle shape. Bring the bottom right corner to meet the edge of the folded triangle and crease. Open the paper.

**2.** Fold the bottom left corner to meet the top edge. Bring the top right corner to meet the edge of the folded triangle. Open the paper.

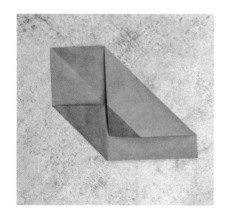

**3.** Fold the bottom left corner to meet the first diagonal crease. Fold the top right corner to meet the edge of the folded triangle, taking care to line up all existing creases. Open the paper. Repeat on the other side, folding the top left corner to meet the first diagonal crease and bringing the bottom right corner to meet the triangle's edge. Open the paper.

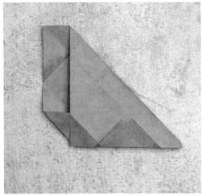

**4.** Fold the bottom left corner to meet the first diagonal crease. Bring the top right corner to meet the triangle's edge, taking care to align all existing creases. Note that this fold extends the edge of the triangle approximately ¼" past the bottom edge of the paper. Open the paper. Repeat on the other side, folding the top left corner to meet the first diagonal crease and bringing the bottom right corner to meet the triangle's edge. Open the paper.

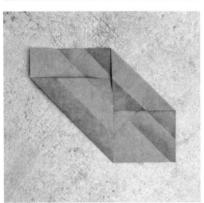

**5.** Fold the bottom left corner to meet the second to last diagonal crease. Bring the top right corner to meet the edge of the folded triangle. Open the paper. Repeat on the other side, folding the top left corner to meet the second to last diagonal crease and bringing the bottom right corner to meet the triangle's edge. Open the paper. You have your grid.

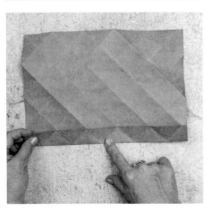

**6.** Turn the paper over. One at a time, fold the paper up to create horizontal creases where the diagonal creases intersect. Note that the horizontal creases are in the opposite direction as the diagonal creases. The direction of these creases is important to create dimensionality. If all the creases are in the same direction, the band will lie flat. Lay the paper flat and refold each horizontal crease firmly.

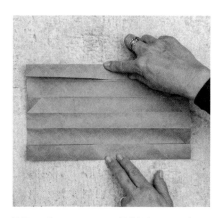

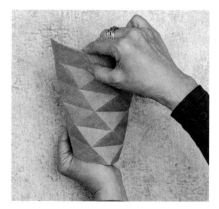

**7.** Turn the paper over. Fold the top edge inward along the first crease. Fold the bottom edge inward also.

**8.** Turn the paper over and bring the two short sides together, creating a tube. You will see the sculptural shape emerge. The centers of the diamonds should indent while the sides of the diamonds should angle toward you. Gently adjust the diamonds into shape if they are stuck.

Adjust the width by placing the paper around your bottle and cutting the wrap so that there is approximately a 2" overlap. Interlock the wrap by sliding one side into the top and bottom folds of the opposite side. Note that it's best to keep the top half tighter than the bottom half as you slide the wrap over the bottle. The top will expand to fit.

# Furoshiki Two-Bottle Wrap

On the day my son proposed to his fiancée, I used this technique to wrap two champagne bottles. The handle built into the wrap made transporting the gift effortless despite a hike to a secluded location through some vineyards for a surprise family celebration. I still recall the crisp fall air, the glimmer of the sun hitting the linen tablecloth, hand-picked flowers on the picnic table, champagne glasses on a makeshift tray, and the furoshiki-wrapped bottles—one for her, one for him, yet wrapped together. It would be the first gift our son and his fiancée would open as an engaged couple on an unforgettable day.

## WHAT YOU NEED
- 35" × 35" furoshiki or piece of fabric

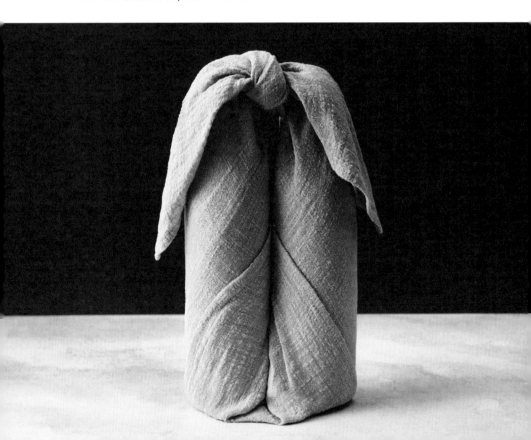

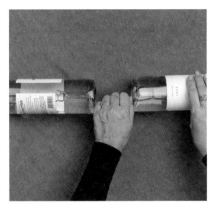

**1.** Lay the furoshiki in a diamond shape and stand the bottles in the center. Lay the bottles down to the sides with the bottoms facing each other, a fist's width apart.

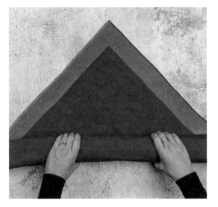

**2.** Wrap the bottom of the cloth over the bottles. Gently roll the bottles toward the top, pushing inward to tighten the roll as you go.

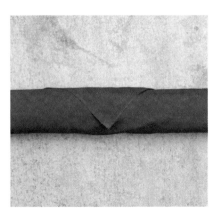

**3.** The top point of the fabric should land in the center between the two bottle bottoms.

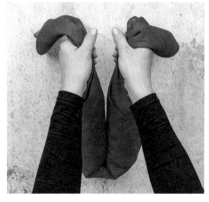

**4.** Pull the sides together, standing the bottles upright, and tie a Basic Furoshiki Knot (page 62).

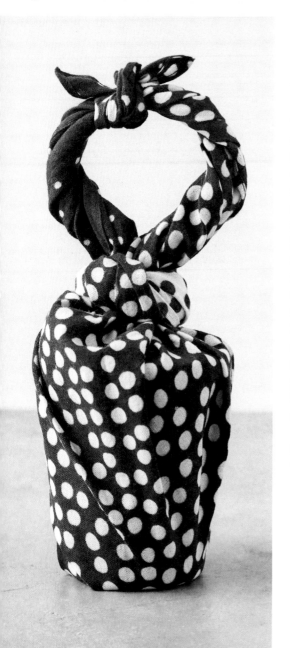

# Furoshiki Jar Wrap

The art of wrapping has a way of elevating a seemingly ordinary item into something that feels special. I experienced such a transformation using this method to wrap a jar of salt. The dramatic nature of the twist of the fabric with a knotted handle is so impressive, it brought attention to the fact that this "ordinary" gift of salt was in fact extraordinary, made with a combination of unique herbs, imported from France, and intentionally selected. The artfulness of the wrap subtly lets your gift recipient know "I found a little something special that made me think of you."

**WHAT YOU NEED**
- Furoshiki or scrap fabric to fit the gift

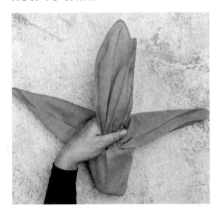

**1.** Orient the fabric in a diamond shape and stand the jar in the center. Lift the top and bottom corners of the fabric together. Holding the tips with one hand, grab the fabric in the other hand, sliding your fist to the top of the jar.

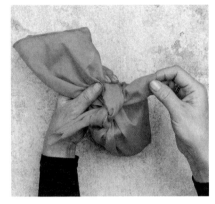

**2.** Wrap the right corner of the fabric around the back to the front left. Repeat on the left side, wrapping to the front right. Tie the two sides together in a single knot.

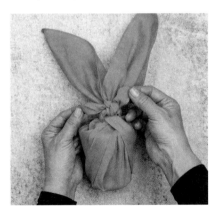

**3.** Bring the two ends of the knot to the back and tie a Basic Furoshiki Knot (page 62).

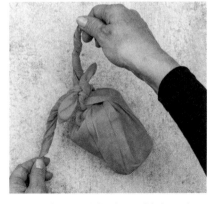

**4.** With the remaining loose fabric, twist both ends in the same direction until the cloth is tight all the way to the top. Tie a Basic Furoshiki Knot at the ends to create a handle.

# Furoshiki Canister Wrap

This traditional furoshiki wrap is known as Hana Tsutsumi, or Flower Wrap. I'm awestruck and filled with gratitude for the way this method easily adapts to any shape. I simplified a step by using a rubber band, an American shortcut method in lieu of the traditional tying technique. With one movement of a hand, the fabric gathers around a circular object, folds aligning themselves naturally without effort, creating a beautiful wrap. You see this philosophy of design in the kimono as well. You adjust the fabric of a kimono through folding and wrapping to fit the shape of the body, just as the furoshiki molds itself into the shape of the gift. There is something forgiving and generous about this approach to wrapping, clothing, and life.

## WHAT YOU NEED
- Furoshiki or scrap fabric to fit the gift
- Rubber band

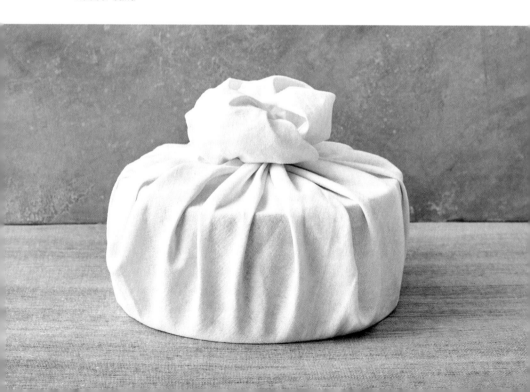

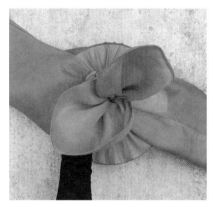

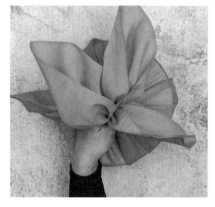

**1.** Orient the furoshiki in a diamond shape and place the item in the center. Lift the top and bottom corners of the cloth. With the other hand, grab hold of the fabric and slide your fist to the top of the canister.

**2.** Bring the remaining two corners of the cloth into your fist and secure with a rubber band.

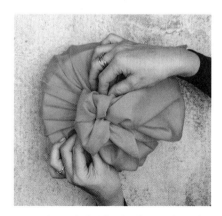

**3.** Let the ends fall freely, then tuck each one under the folds into the rubber band. Arrange like a flower.

# Honeycomb Wrap

Recyclable and biodegradable, artfully designed, and durable, honeycomb packing material has my enthusiastic admiration not just for cushioning items during transit but as a creative wrapping paper for gifts. Its pliable quality—molding its shape to what it covers—makes wrapping oddly shaped, cylindrical, or round objects effortless. I often wonder why we keep such a beautiful invention hidden inside boxes. How many other exquisite, environmentally conscious design solutions for wrapping gifts can we find in unexpected places? We need to bring them into the light.

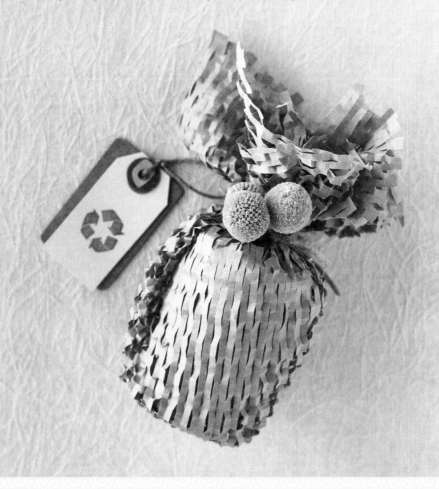

# Brimming with Bounty Gift Bag

Cutting, reshaping, and upcycling the shopping bags we seem to endlessly accumulate makes the ideal packaging for homegrown things—precious jewels from the garden, ripe fruit from the tree, clippings from the flower bed. A lovely presentation doubles the joy of gifting these treasures from the soil. While you may question why you'd even bother to cut the bag rather than just reuse it as is, the personal engagement and effort invested in rebuilding the old bag into something new is transformative. You will see.

## WHAT YOU NEED
- Paper shopping bag with handles
- Scissors
- Hole punch
- Two 1" brass fasteners (or four fasteners, if the items in the bag are heavy)

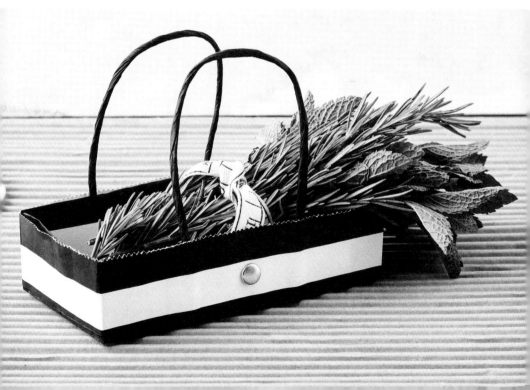

HOW TO WRAP

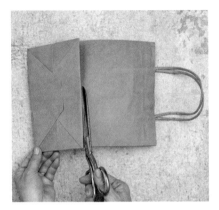

**1.** Collapse the shopping bag so it lies flat, bottom end facing up. Cut off the bottom of the bag using the top edge of the bottom portion of the bag as your guide.

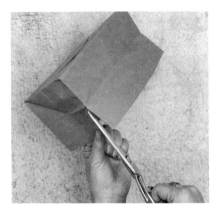

**2.** Open the bottom portion of the bag. Cut slits halfway down all four corners to make flaps. The natural fold in the bag conveniently marks the halfway point.

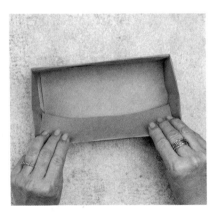

**3.** Turn all the flaps inward, creating a shallow box.

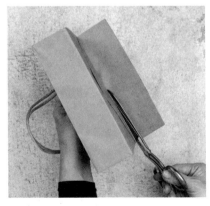

**4.** Trim the portion of the bag with handles to match the depth of the box.

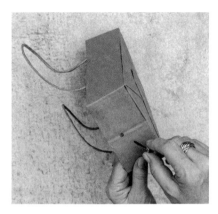

**5.** Insert the box into the handled portion of the bag. The fit should be fairly exact. Punch holes in the middle of each short or long side and insert brass fasteners to hold the pieces together.

## Variations

» For a deeper bag, skip step 4.
» To add decorative touches, use scrap paper to cover or collage the outside of the gift bag.

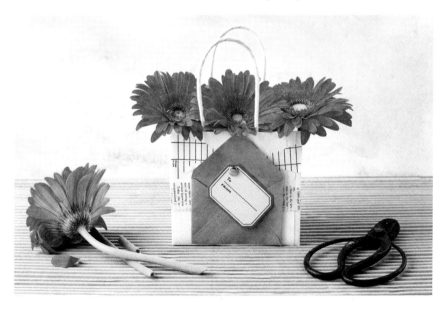

# With All One's Heart Gift Bag

My mother's love was not spoken in words but expressed through the meticulous care she put into my school lunches, a memorable tradition I carried forward into my own family. If you ever have the opportunity to pack a lunch for someone you care about, try this simple design to amplify your loving intentions. Choose any paper bag that feels right for the size and quantity of items in your gift. If the bag feels too roomy, you can also trim the top before folding to create a shallower space.

**WHAT YOU NEED**

- Paper bag
- Scissors

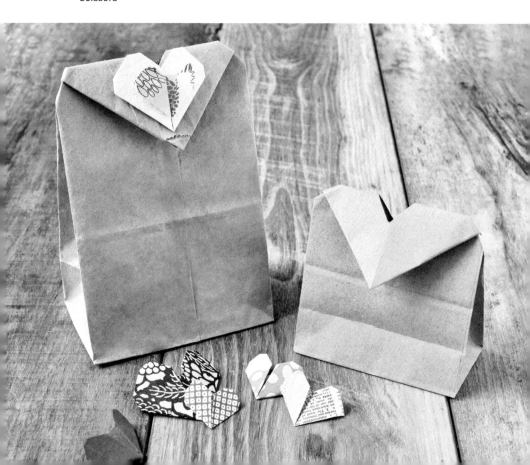

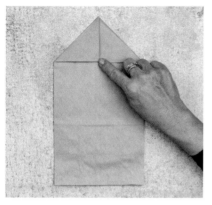

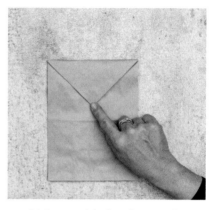

**1.** Trim the top edge to a straight line if it's not even or to make the bag shallower. On the flat side of the bag, fold the two top corners to the center line, creating two triangles.

**2.** Fold the top of the bag downward at the base of the triangles.

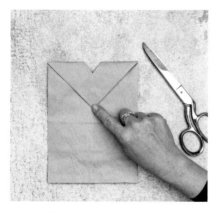

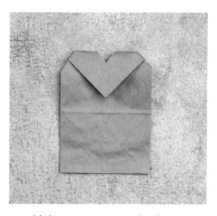

**3.** Using the center line as a guide, cut a triangle out of the top of the flap.

**4.** Fold the two top corners back at an angle, completing the heart shape. Open the bag to fill with your gift and refold.

# Furoshiki Carryall

I remembered this furoshiki wrapping method when I needed a bag at the farmers' market. My makeshift sack helped me carry home a variety of fruits and vegetables with ease and reminded me how this style of wrapping is suitable, with an adjustment of the knot, for packaging any assortment or bundle of items.

**WHAT YOU NEED**
- Furoshiki or scrap fabric to fit the gift

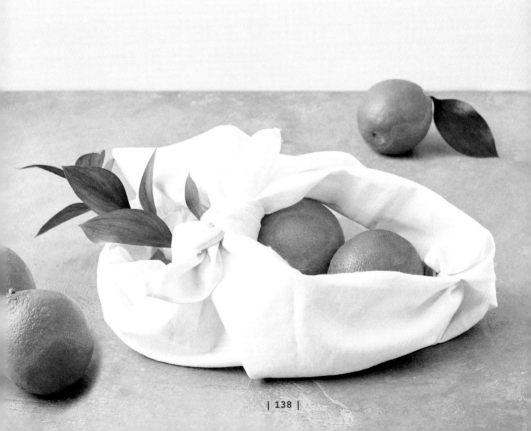

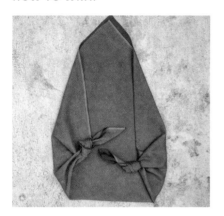

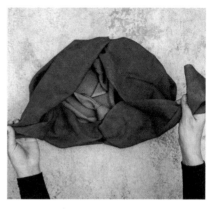

**1.** Orient the furoshiki in a diamond shape, design-side up. Bring the bottom point to meet the top point. Tie a single knot in the left point. Repeat with the right point. Lay the knots inside the triangle.

**2.** Picking up the top corner, bring the top layer of the fabric down and turn the fabric inside out to create a bag, making sure the knots stay inside the bag.

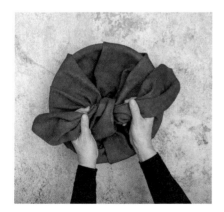

**3.** Place items inside the bag and tie the remaining two ends in a Basic Furoshiki Knot (page 62), adjusting the length for a snug fit.

# Favor Bag

Traditionally, this pouch design is made with adhesives, but you can save this step by upcycling a sealed envelope instead. The puffed construction is ideal for odd-shaped items or things you want to protect from getting crushed. I used this wrapping concept instead of purchasing bags one year, hanging Advent gifts for my children to count the days before Christmas.

I repurposed a letter-size envelope for this template, but you can use smaller or larger envelopes for bags of different sizes.

## WHAT YOU NEED

- Envelope
- Scissors
- Hole punch
- Ribbon, twine, branch, or other material for tying

**1.** With a sealed envelope, trim one side, creating an opening along a short end.

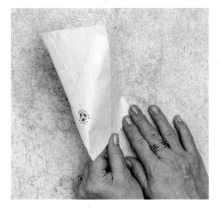

**2.** Press the folded edges toward each other to form the envelope into a three-dimensional triangle. Pinch the new edges of the bag to hold the shape.

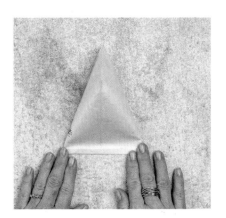

**3.** Fold over the open end twice to close. Punch two holes through the layers of the folds. Insert ribbon or twine and tie.

## Variations

There are many ways to embellish the favor bag. I love using elements from nature or buttons.

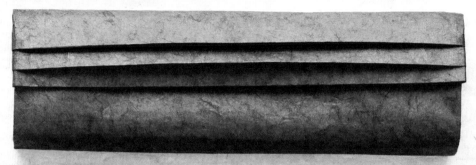

Straight pleats

Fan pleats

Alternating pleats

# Sculpting Paper

The pattern of lines created by folding paper on top of itself, sometimes in different directions, is called pleating and is an eye-catching enhancement when applied to gift wrap. Be aware that pleating requires extra material. Before you cut the paper for your gift wrap, test out some pleating designs on scrap paper. When you've decided on the size and number of pleats you'd like, measure how much extra length or width you'll need in the wrap to achieve that effect. Alternatively, a waste-free way to incorporate pleats into your wrapping is utilizing cut-offs to create a pleated band and attaching it to your gift.

## Hidden in Plain Sight

Beyond having aesthetic value, folds carry meaning in Japanese wrapping practices. An odd number of pleats, for example, symbolizes celebratory and happy occasions. An even number of pleats signifies the opposite and is appropriate in unfortunate circumstances such as a funeral.

Similarly, wrapping with folds opening to the right acknowledges celebrations. Wrapping in the opposite direction, with folds opening toward the left, acknowledges misfortune or sadness. Embedded and recognized in this folding style is an expression of sympathy. The most poetic explanation of these directional folds is that the right side symbolizes the sunrise in the east and the left, the sunset in the west.

This cultural tradition of encoding meaning in silent, tactile ways resonates with me. I didn't learn that folds carried specific meaning until I was an adult. I often reflect on how many gifts I unwrapped without thought or awareness of what the wrapping itself might be saying. What else might I be missing, not experiencing, not feeling because I'm not noticing or aware?

## FOUNDATION FOLDS

Pleating always begins with the same first steps.

**1.** Fold the bottom edge up approximately ½" and crease. This creates a clean, straight edge for what will be exposed on your package.

**2.** The subsequent fold size depends on the size of the pleat you want. The bigger the fold, the larger the pleat. Fold up to your desired pleat width and crease. Fold the number of pleats you wish to have. The folded crease from the previous step counts as your first pleat.

**3.** Unravel all folds except the first and turn the paper over.

# Straight Pleats

Whenever I see a line of straight pleats embellishing a gift, I wonder what they are meant to convey. The skirtlike pants called hakama—worn by practitioners of the modern martial art kendo—are lined with five straight pleats that represent virtues such as humanity, justice, courtesy, and sincerity. As I fold paper into pleats, my fingers applying deliberate pressure, I reflect on the virtues that the art of wrapping embodies. What would you like the pleats to mean for you and the person you are gifting to?

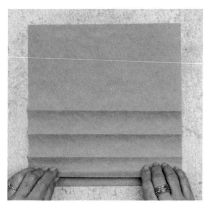

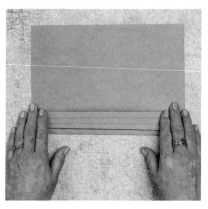

**1.** Create your foundation folds. (See page 144.) Keep the first fold tucked under, as this will become the visible edge. With that fold facing downward, pull the first crease line toward the fold, keeping the edges parallel. Crease.

**2.** Repeat for each of the crease lines you folded.

# Fan Pleats

While the name suggests using this design as a fan, I've discovered its shape can represent many different forms. Depending on how it's folded and positioned, the fan becomes a tree trunk or a pyramid. Placed sideways, it can look like a shooting star. Enjoy discovering its many expressive possibilities!

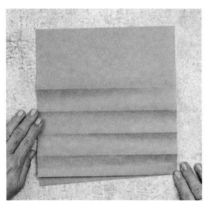

**1.** Create your foundation folds. (See page 144.) Keep the first fold tucked under, as this will become the visible edge. With that fold facing downward, pull the first crease line toward the edge at a diagonal. The right corner of the new fold should meet the right corner of the first fold.

**2.** Pull the next crease line down at the same angle. The right corner of the new fold should meet the right corners of the previous pleat and foundation fold.

**3.** Repeat step 2 for each of the crease lines you folded, creating a fanlike shape.

# Alternating Pleats

The directions that follow switch evenly between pleats at opposite angles, but there is so much room here for creativity. You can alternate in random order, alternate in a rhythmic pattern, add a straight pleat between each cross pleat, or vary the angles of the folds.

**1.** Create your foundation folds. (See page 144.) Keep the first fold tucked under, as this will become the visible edge. With that fold facing downward, pull the first crease line toward the edge at a diagonal. The right corner of the new fold should meet the right corner of the first fold.

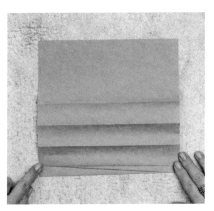

**2.** Pull the next crease line down at an opposite diagonal. The left corner of the new fold should meet the left corner of the previous pleat.

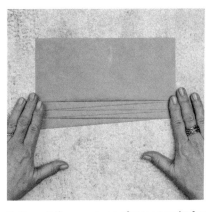

**3.** Repeat the sequence of steps 1 and 2 for each of the crease lines you folded.

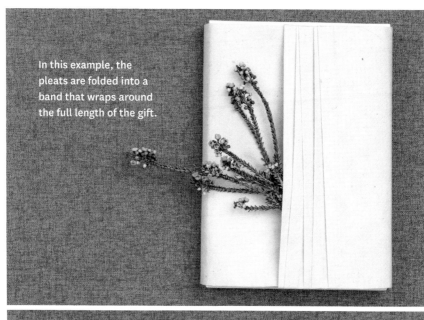

In this example, the pleats are folded into a band that wraps around the full length of the gift.

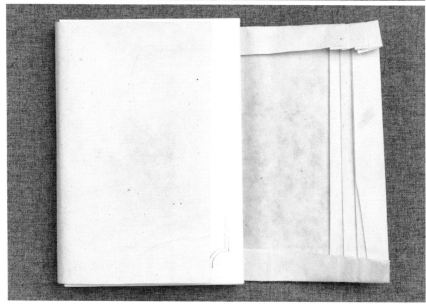

In this alternative, a separate pleated band is folded over the main wrap.

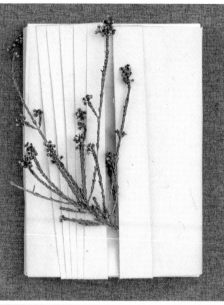

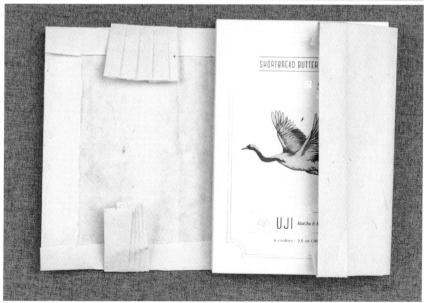

# Beauty in the Tear

Depending on the look and feel you want, you can choose from various paper tearing techniques that bring about different aesthetic results. Tearing the paper toward you is a good general rule.

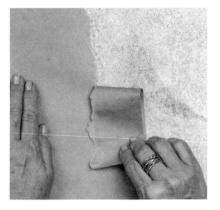

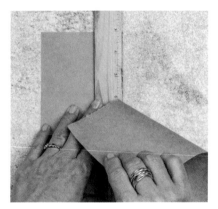

Tearing deliberately and slowly creates a more controlled, distressed, jagged look. This is my favorite way of tearing, creating uneven wavelike textures.

Using a ruler to hold the paper down while tearing against the ruler creates a straight tear.

An artist friend gave me a tip on how to tear fibrous washi paper by taking a paintbrush with water and painting a line of the desired tear. Slowly tearing along the wet line creates a stunning featherlike texture.

# Trash to Treasure

It takes a bit of courage to deem wrinkled paper worthy for use as gift wrap and present it to others. I overcame my fear in the commitment I made to be more conscious of environmental sustainability. Inundated with large amounts of packing paper in the boxes that were delivered one day, I started to artfully crumple each wrinkled sheet, resulting in an impressive stack of paper. What would be the aggregate impact if we repurposed paper multiple times rather than recycling it after one use?

Beyond lightening our footprint on the planet, reused paper can have immediate, pragmatic advantages. Crumpling paper eases its stiffness, making it flexible enough to wrap bulky soft items.

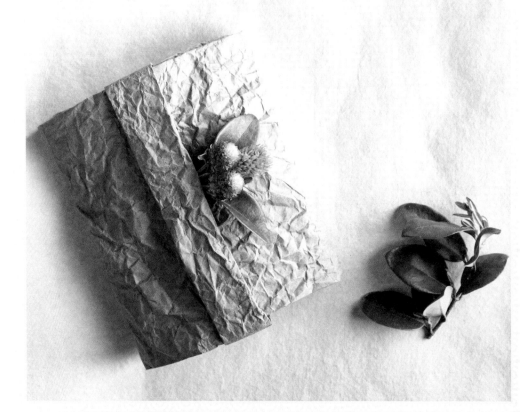

# The Art of Texture

There is a method to crumpling paper. Mathematicians at Harvard University recently discovered that paper crumples in predictable patterns. I personally experimented by watching a machine crumple paper and followed the mechanical example using my hands.

**1.** Shape the paper into a loose tube shape, holding the top of the paper with one hand and the bottom with the other. Bring your hands together, smashing the paper like a vise.

**2.** Crumple the paper in one hand into a perfectly tight ball shape.

**3.** Unravel and take a close look at the beauty of the intricate geometric patterns.

# Basic Band

I have a vivid memory of a gift I received. A sheet of washi paper wrapped around a wooden box. A single fold centered the band, a human touch visible in the crease of the paper. The top and bottom of the box were left exposed. I remember feeling soft anticipation and curiosity, awakening in me a realization that even the simplest band around a gift can still feel very special.

## WHAT YOU NEED

- Paper to fit around the gift
- Scissors

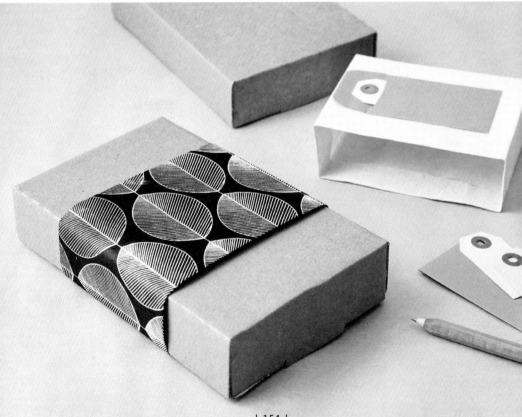

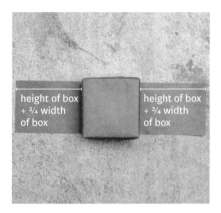

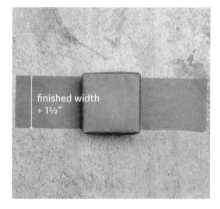

**Length of band:** The paper should wrap three-quarters of the way around the top width of the box in both directions. Cut the paper as straight and evenly as possible to ensure the edges of the band align.

**Width of band:** The width of the band is a design decision. Once you've determined the finished width you want, add 1½" and cut. (For example, if you want a 3" band, the paper width should be 4½".)

## HOW TO MAKE IT

**1.** Fold in both long edges ¾".

**2.** Fold in one short end of the band approximately 1".

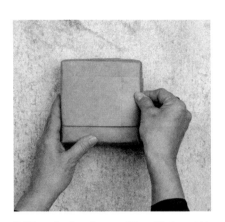

**3.** Wrap the band around the gift. Insert the folded end into the unfolded end. Push the paper inward as far as it will go to secure the band. This may require some tugging and tuning. Pinch creases into the band where it wraps over the edges of the box.

# Variations

***Embellished Band:*** Attach embellishments such as the Gratitude Bow (page 167) or Paper Flowers (page 174) for dimensional decoration. Select a material for the band that is sturdy enough to hold the embellishment. Holding the band securely on the gift, pierce the material with a brass fastener and secure the embellishment.

***Pleated Band:*** Cut paper according to the Basic Band directions, adding extra length to accommodate your desired number of pleats. Follow the directions for pleating (see page 143). Once the band is pleated, follow the directions for the Basic Band.

# *Waste Not, Want Not*

When cutting paper to fit a gift, there are always remnants, and bands make good use of these often-discarded pieces. For ways to use the smallest scrap paper, see the Kaleidoscope Bow (page 171). Gift tags are also an opportunity to creatively use paper snippets and honor our resources.

# Interlocking Band

This simple method of binding works well when made from card stock or other heavyweight paper, such as cut-offs from the Gratitude Bow (page 167). The interlocking wings can face upward as a decorative feature on the top of the gift or hide on the bottom of the gift. Sturdy paper makes this band ideal for supporting heavier embellishments. Note: If you are using an embellishment with a brass fastener, attach it to the band before interlocking the ends.

For a Subtle Reveal (page 37), use this band on its own. Punch holes in the band or cut the ends in a shaped line, like a wave. Have fun being innovative.

**WHAT YOU NEED**
- Heavyweight paper to fit around the gift
- Scissors

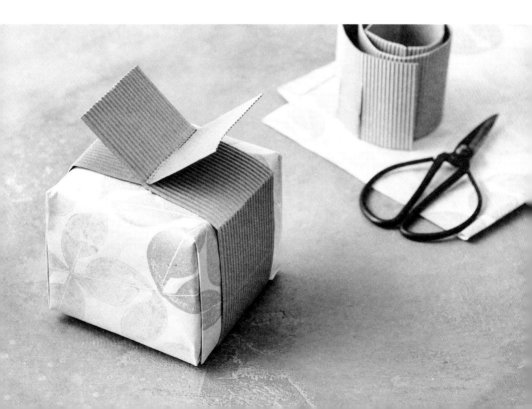

### HOW TO MEASURE PAPER FIT

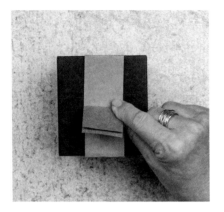

The length should completely wrap around the item, with enough of an overlap to grab two ends of the overlapped paper strip together (about 1½" on each side). The width is a design decision. There is no wrong choice!

**Note:** Since you are using heavy paper, you won't fold the edges. To get neat, even widths, you may want to mark the cutting lines with a ruler.

### HOW TO MAKE IT

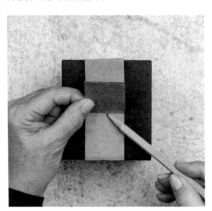

**1.** Wrap the band around the gift, matching the ends evenly. Hold securely and mark the length of the overlap on each side.

**2.** Remove the band. At your overlap marks, cut one mark three-quarters of the way to the top edge and the other mark three-quarters of the way to the bottom edge. Wrap the band around the gift again, sliding the cuts together to interlock the overlapped ends.

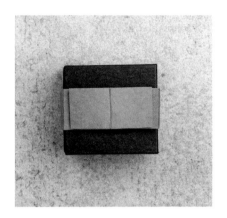

**3.** Cut (if needed to shorten) and flatten the ends flush against the back of the package. Alternatively, you may leave the ends upright as a feature on the front of the package.

# Nature Band

We don't often look to nature for sustainable solutions for our gift wrapping, but whenever I use a fallen branch, the end roots of a flower, or a stick made of bamboo to secure a package, I realize that nature provides many answers to our wrapping needs if we open our awareness. In holding nature's gifts with reverence and bringing the earth's presence into my wrapping rituals, I found a way to reconnect with nature, bringing me unexpected joy.

### WHAT YOU NEED

- Paper to fit around the gift (see Basic Band on page 154 for how to measure paper fit)
- Scissors
- ¼" hole punch
- Small twig or bamboo cocktail skewer
- Other items foraged from nature (optional)

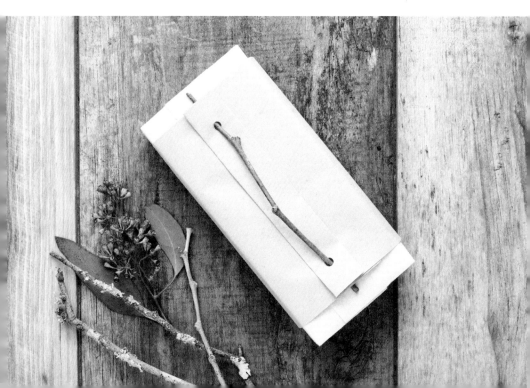

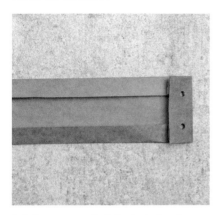

**1.** Follow steps 1–2 of the Basic Band (page 154). Punch two holes at one end.

**2.** Wrap the band tightly around the item. With the punched end on top, tighten the band, and mark the placement of the holes on the other end.

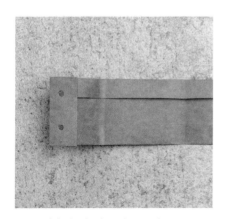

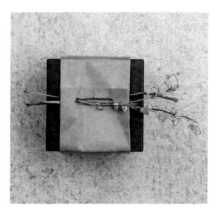

**3.** Punch holes in the other end.

**4.** Align holes through all layers and weave the twig through the band. Start under the band, go up through the first holes, down through the facing holes, and out the other side.

# Button Binding

I collect buttons: the extra buttons sometimes provided when buying a garment, the ones left behind by my mother in her old sewing box. They are all saved in a vintage glass jar, ready to be used at a moment's notice as embellishment for a gift. As I put my hands into the jar, the buttons falling through my fingers, I marvel at the sheer variety of sizes, color shades, and designs of this utilitarian little disk that holds our clothing together. I hunt for the ones that speak to me about the person I'm wrapping for or the occasion of the gift.

**WHAT YOU NEED**

- Button
- Spool of thread
- Scissors

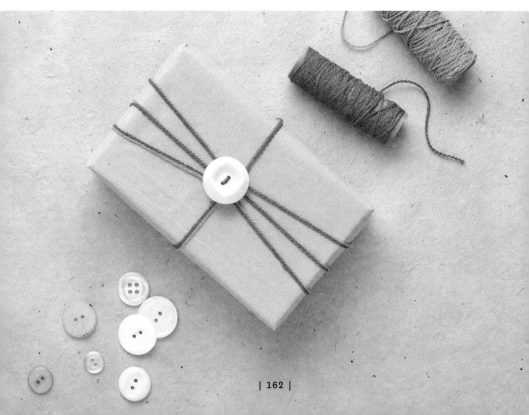

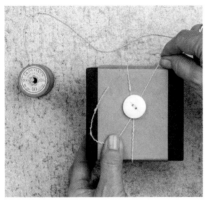

## HOW TO MAKE IT

**1.** Thread the button so both ends are at the back, with most of the thread on one side and a short tail on the other. Tie a knot. Holding the button in place by the short length of thread, wrap the long length of thread around the package, then circle it counterclockwise around the thread at the back of the button.

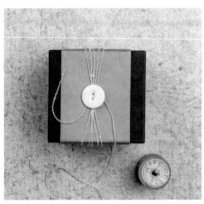

**2.** Wrap the thread around the package again, then circle it clockwise around the thread at the back of the button. Repeat as many times as you want, alternating between clockwise and counterclockwise turns around the back of the button, which will create the alternating thread pattern seen on both sides of the button.

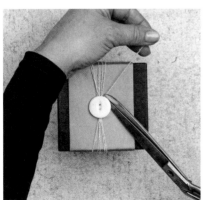

**3.** Tie the two thread ends together behind the button in a double knot and trim for a neat finish.

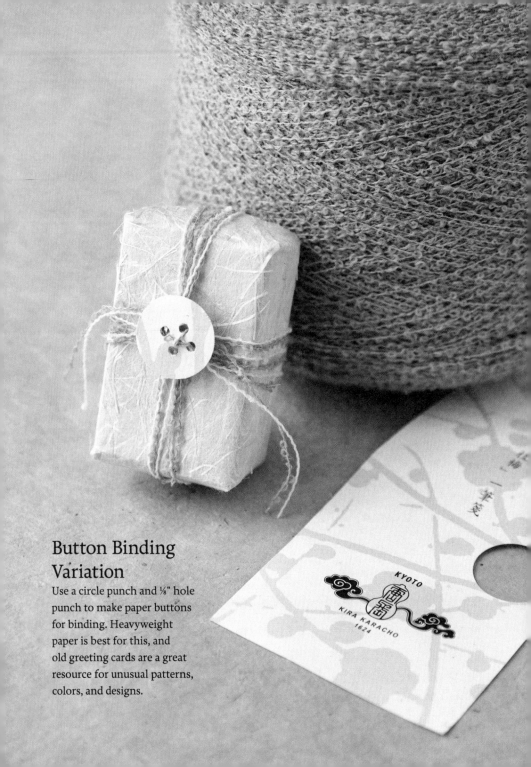

## Button Binding Variation

Use a circle punch and ⅛" hole punch to make paper buttons for binding. Heavyweight paper is best for this, and old greeting cards are a great resource for unusual patterns, colors, and designs.

# *Thread Binding*

One of the easiest ways to embellish a gift—my favorite way—is to wind thread, twine, or string around and around a package in a weblike design. Depending on the color, the texture of the string, and the number of times it's wrapped around the item, the result is an intricate interweaving that is unique every time.

I decorate my shelves with spools of thread organized by color tones or occasions: the browns and creams in one area, a collection of reds, silvers, and whites gathered for holiday gifts. At my local flea market, I was thrilled to find a cornucopia of sewing thread in a multitude of colors like a crayon box. I hope you have as much fun as I do finding, displaying, and using such treasures.

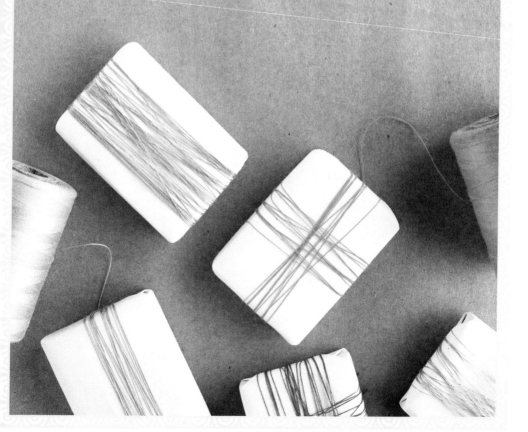

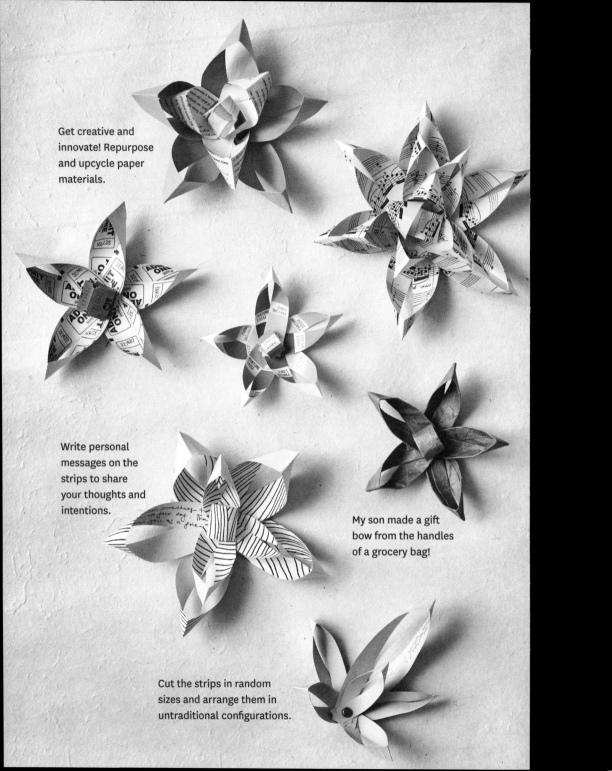

Get creative and innovate! Repurpose and upcycle paper materials.

Write personal messages on the strips to share your thoughts and intentions.

My son made a gift bow from the handles of a grocery bag!

Cut the strips in random sizes and arrange them in untraditional configurations.

# Gratitude Bow

The pointed leaves of a poinsettia plant were my original design inspiration for this sustainable version of the iconic gift bow. Cutting a file folder into strips with the folded edge intact, I could shape the paper into pointed shapes with little effort. I enjoy the sturdiness of the material and its ease of use, but any paper is suitable as long as you crease it first. The bow can be neatly collapsed by stacking the file folder strips and inserting the brass fastener through the punched holes. This makes it easy to store away for reuse or even making a bunch ahead of time, so you always have a bow on hand.

The finished bow shown here is 8", but you can create bows of any size by adjusting the measurements of the paper strips. See page 170 for variations.

## WHAT YOU NEED

- File folder, card stock paper, or any scrap paper of comparable weight
- Scissors or paper cutter
- ⅛" or ¼" hole punch
- 1" brass fastener

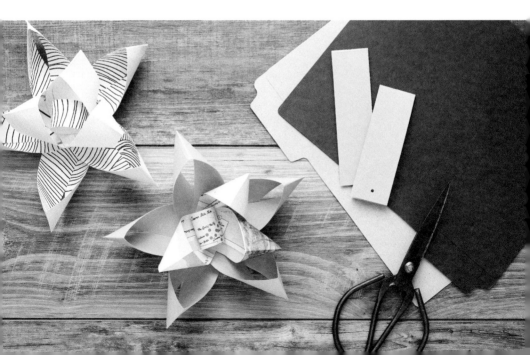

# Hopeful Intentions

I participated in an art installation titled *Hopeful Intentions*, created in collaboration with students from Tohoku, the northeastern region of Japan devastated by the 2011 earthquake and tsunami.

I asked the students to write visions for their future and their communities on colorful cut-off strips from old file folders. So much of what they expressed was rooted in gratitude. By recollecting what they lost and missed, they felt grateful for all they had. These students, who had lost family, schoolmates, homes, and community, imagined a future that revitalized things that held meaning for them.

The students then shaped their strips of hopeful intentions into bows, as though they were shaping their destinies in the process. In the end, hundreds of gift bows were lined up, each one holding within its folds a student's dreams, courage, resilience, and sense of hope. Inspired by their work, I named my design for this gift embellishment the Gratitude Bow.

## HOW TO MAKE IT

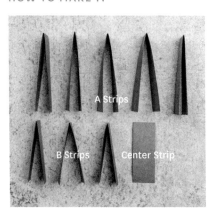

**1.** Begin with the file folder in its folded shape (or your chosen paper folded in half). Cut strips in the following sizes and quantities (with the folded edge of the folder or paper as one of the short edges for each strip):

- 5 strips at 5" × 1½" (A Strips)
- 3 strips at 4" × 1½" (B Strips)

  **Note:** These are the folded measurements.

Cut a single strip measuring 4" × 1½" from the unfolded section of the paper (Center Strip).

**2.** Punch a hole through both layers of the A and B Strips in the center of the open short edge, about ¼" from the bottom edge. Punch a hole at the center of both short edges of the Center Strip.

**3.** Wrap the Center Strip into a tube. From the inside of the tube, insert the shank of a brass fastener through both holes. This is the center of the bow.

**4.** Open one B Strip and align the holes as shown.

**5.** Place the center of the bow created in step 3 on top of the B Strip and insert the brass fastener through the aligned holes.

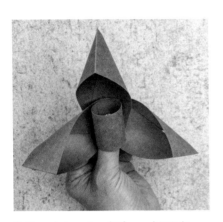

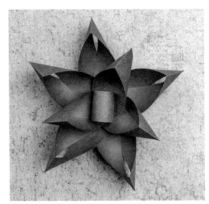

**6.** Repeat steps 4 and 5 for each B Strip, forming the first layer of the bow.

**7.** Continue the same process with the A Strips, inserting the fastener through the aligned holes inside each loop. Shape the bow. The fastener allows for movement of the strips.

## Variations

***Small Bow:*** You can make bows of any size using the same technique. For a small 4" bow, use only one layer of folded strips. Cut strips in the following sizes and quantities:

» 5 strips at 2½" × 1" (folded)
» 1 strip at 3"× 1" (Center Strip, unfolded)

***Deluxe Bow:*** You can also add more strips and more layers to your bow for greater dimension. Cut strips in the following sizes and quantities:

» 6 strips at 4½" × 1" (A Strips, folded)
» 4 strips at 3½" × 1" (B Strips, folded)
» 4 strips at 2½" × 1" (C Strips, folded)
» 1 strip at 3" × 1" (Center Strip, unfolded)

## Attaching Embellishments

If you want to attach a bow, flower, or heart to your gift without tape or glue, use a brass fastener to secure the embellishment to a paper band (see page 154). Make sure the material of the band is sturdy enough to hold the embellishment in place.

# Kaleidoscope Bow

This wrapping embellishment shows how even the smallest piece of scrap paper can be upcycled into a beautiful accent for your gift. Here you will fold little squares of paper and then experiment with piecing them together in different configurations. The endless array of combinations that emerges reminds me of looking through a kaleidoscope. I love that *kaleidoscope* literally means "observer of beautiful things" or "an instrument for seeing beautiful shapes."

**WHAT YOU NEED**
- Scrap paper
- Scissors
- White glue

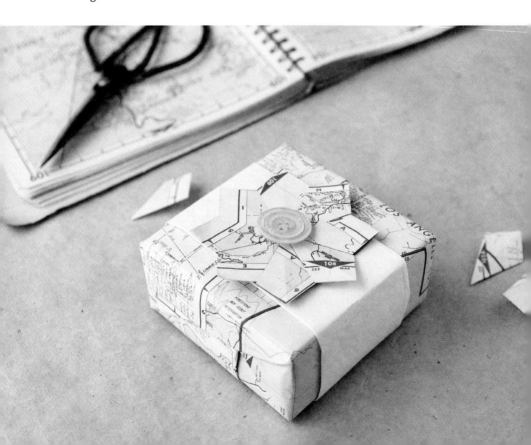

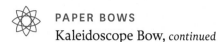
HOW TO MAKE IT

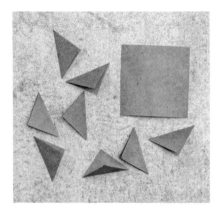

**1.** Cut eight 1½" square pieces of paper and one 3" square. Fold all the small squares into triangles and unfold.

**2.** Fold each small square into a kite shape, bringing two corners to the center crease.

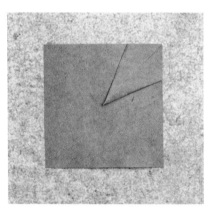

**3.** Spread glue on the 3" base. With the flaps facing downward, align the right angle of one kite with one corner of the base.

**4.** Glue down another small piece, flush to the first. Repeat with the remaining pieces, affixing them in a radial pattern.

# Variations

» Glue the small pieces to the base flap-sides up.
» Glue the small pieces to the base in an alternating pattern of flap-sides up and flap-sides down.
» Make a smaller version and stack it on top of the base. Add a button.
» Stack several sizes on top of each other, varying the design of each layer.

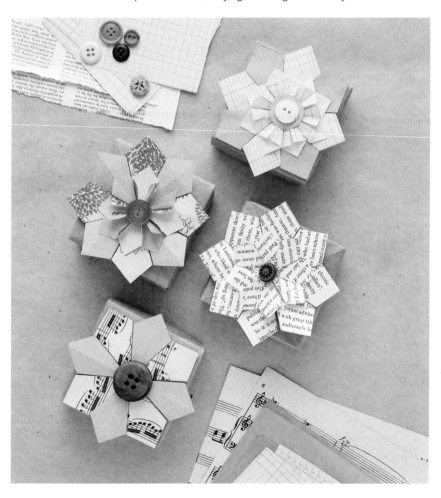

# Tissue Paper Flower

I love the look and feel of sewing patterns as wrapping, but any tissue-weight paper can become a ruffled, layered, decorative accent to your gift wrapping. The tissue sheets that often accompany gifts you receive or purchases from stores are perfect candidates for reusing and upcycling. This design pays homage to nature's delicate yet strong flower petals. The finished flower looks different every time depending on the shapes you cut, how many layers you have, and how you sculpt each layer. The result is always imperfectly perfect, handmade.

**WHAT YOU NEED**

- Tissue paper
- Scissors
- ½" or 1" brass fastener

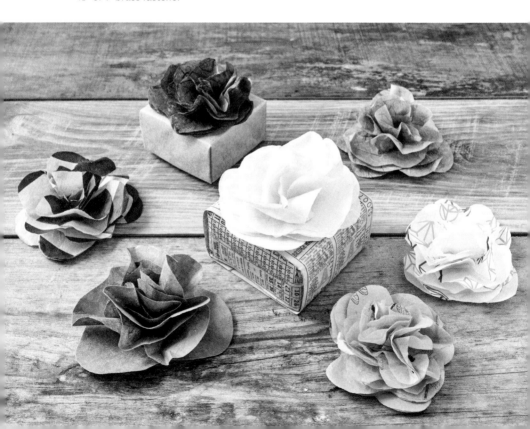

**1.** Fold the tissue paper multiple times into a square or rectangle.

**2.** Cut the paper into a circular shape, with organic, rippling edges. You will end up with a stack of shaped rounds.

**3.** Insert the brass fastener through the center of each layer. When all the layers are attached, secure the fastener.

**4.** Starting at the top, pinch and shape each layer toward the center.

# Cupcake Liner Flower

A creative convergence occurred in the kitchen while baking, inspiring this floral embellishment. A stack of white cupcake liners sat next to a chrysanthemum flower in a vase. The beauty of the tiny petals caught my attention. I started to play with the liners, cutting them in ways that mirrored what I was observing. In this engagement, I began to see the intricate details and appreciate the vibrant complexity found within just a single flower stem.

Experiment with the color of the paper, the size of the liners, the number of layers, how many times you fold the layers, and the shape and depth of the cuts. Every decision creates a different look and feel!

## WHAT YOU NEED

- 5 cupcake liners or lightweight circular paper
- Scissors
- 1" brass fastener

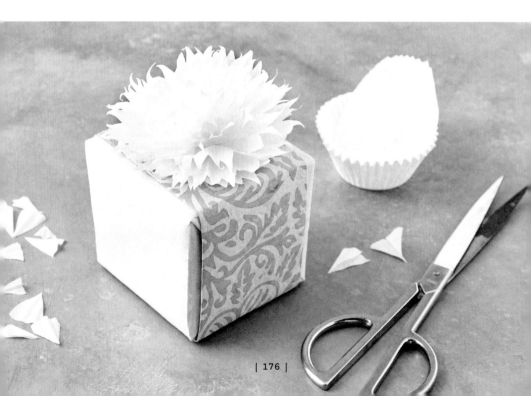

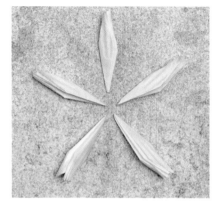

**1.** Flatten one cupcake liner and fold in half, then in half again four more times until you get a thin cone shape. (Adjust the number of folds to your preference.) Repeat for the remaining cupcake liners.

**2.** Cut the top end of each cone-shaped liner into a diamond shape. (Adjust the length of the cuts to your preference.)

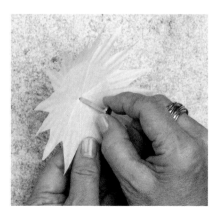

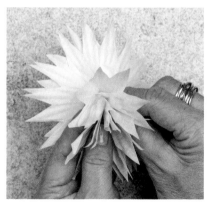

**3.** Open the cupcake liners and insert the brass fastener through the center of one liner at a time.

**4.** As you stack the liners, lift or pinch each one toward the center of the fastener to shape the flower.

# Origami Hearts

These origami hearts bring back a memory of when my youngest daughter and I volunteered at an assisted-living and community center for seniors. For a special New Year's meal that would include residents' family and friends, we wrapped over 150 sets of chopsticks in crisp white pleats of paper and embellished them with origami hearts. The seniors joined us, and my daughter and I had the opportunity to listen to their life stories and share laughs while we all folded together. It was truly a "wrapping with the heart" scenario for everyone, both literally and figuratively.

**WHAT YOU NEED**
- Square sheet of paper (6" × 6" origami paper works well)

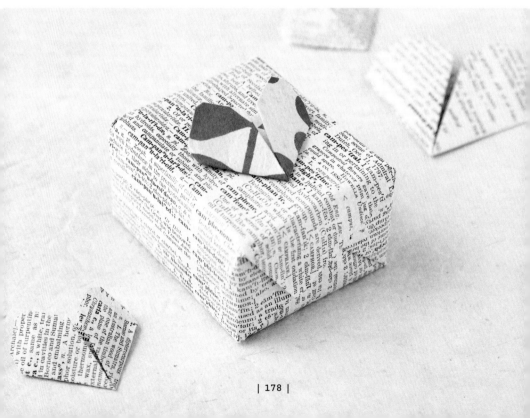

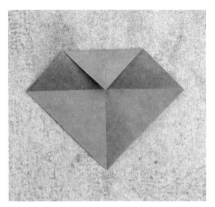

**1.** Fold the paper into a triangle and unfold. Fold the opposite corners together to create another triangle and unfold. You should have an X in the center of the paper. With the paper oriented in a diamond shape, fold the top corner to the center line.

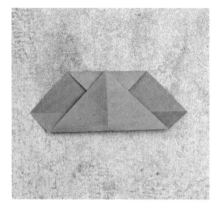

**2.** Fold the bottom corner to the top edge.

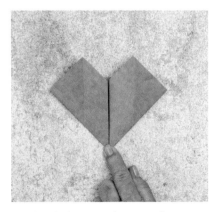

**3.** Bring the bottom edge up to the center line, folding at a diagonal. Repeat on the left side.

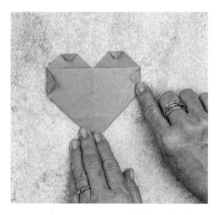

**4.** Turn the paper over. Fold down both top points to create the top edges of the heart. Turn the two side points inward.

# Infinite Heart

I found my inspiration for this design when I realized the Japanese word for gratitude (*kansha*) contained the kanji character for heart (*kokoro*). I wanted to find a way to attach a heart to the Gratitude Bow (page 167) to embody the deeper meaning I sensed in this discovery. Cutting one of my file folder strips in half down the middle, I curled the two ends to form a heart shape and attached it to the bow with a brass fastener. It worked perfectly. There is, however, no need for a file folder, as any paper strip will do the job. You can easily attach the heart to a band as an embellishment, though I recommend making sure the material choice for the band is strong enough to hold it.

WHAT YOU NEED

- Strip of paper
- ⅛" hole punch
- Glue or 1" brass fastener

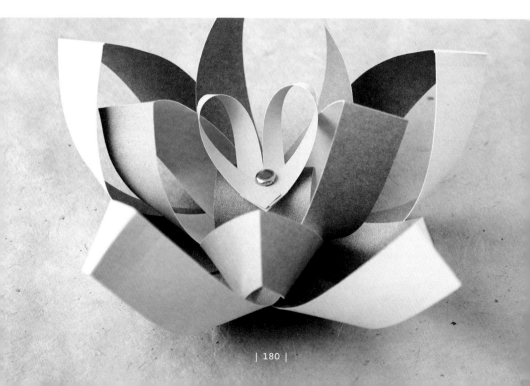

**1.** Cut three-quarters of the way along the center of the strip lengthwise, leaving the last quarter uncut.

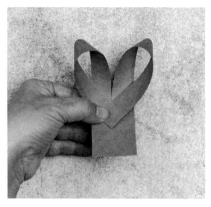

**2.** Loop the loose ends toward the bottom, joining them at a right angle.

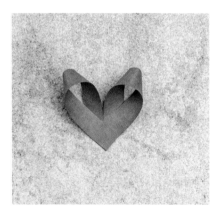

**3.** Trim the excess at bottom. Apply glue to hold the shape or punch a hole through all the layers and secure with a brass fastener.

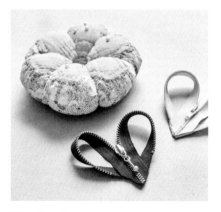

## Variation

Upcycle a garment zipper, partly unzipping it and using the loose ends to form the heart. Secure the ends with tack stitches. Trim the excess at bottom.

# Matchbook-Style Gift Tag

I love matchbox art, a tiny canvas for creative expression with the potential to hold a world of ideas and treasures. I often use my beloved scraps of saved paper to wrap old matchboxes, enclosing personal messages inside and attaching them to my packages as gift tags. This practice gave me the inspiration to create a matchbook-style embellishment, which looks like it holds matches to light a candle but instead carries the light of a heartfelt message of gratitude.

## WHAT YOU NEED

- Heavyweight paper for matchbook
- Contrasting paper for liner
- Scissors
- Glue
- ⅛" hole punch
- Brass fastener

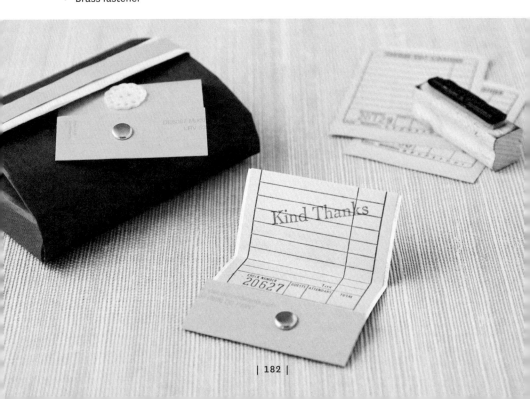

**1.** Cut the heavyweight paper into a 2½" × 5" strip and the liner paper into a 2" × 4½" strip. Glue the liner paper in the center of the heavyweight paper.

**2.** Fold the bottom of the paper up approximately ¾". Punch a hole through the bottom center of the folded edge. Insert the brass fastener and fasten.

**3.** Fold the top edge down so it hits the shank of the fastener. (*Tip:* Folding to the outside of the matchbook first helps position the crease before tucking the flap inside.) Write your message on the liner.

# *To You, From Me, With Gratitude*

Gift tags hold meaning for me as a carrier of my grateful intentions. Before discarding notecards, postcards, brochures, and catalogs, give them one last pass under the inspection of your curatorial eye. Undoubtedly there will be an unusual color, a striking image, lettering, or a pattern that will stand out to you. Cut your favorite parts out—the ones that evoke a memory or a person—and save them for later use as gift tags. Any heavier paper can be cut up in different shapes and used as tags as well.

Punch a hole in the desired location of the gift tag and feed a string through it. To attach a gift tag to a package, I use the larkshead knot.

### HOW TO TIE A LARKSHEAD KNOT

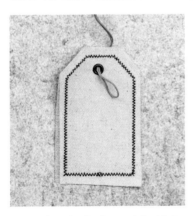

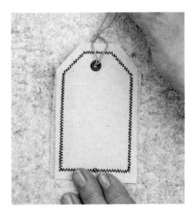

**1.** Cut a length of string and double it. Insert the loop end through the back of the hole of the gift tag.

**2.** Insert the two loose ends through the loop and tighten. Tie the strings onto the gift.

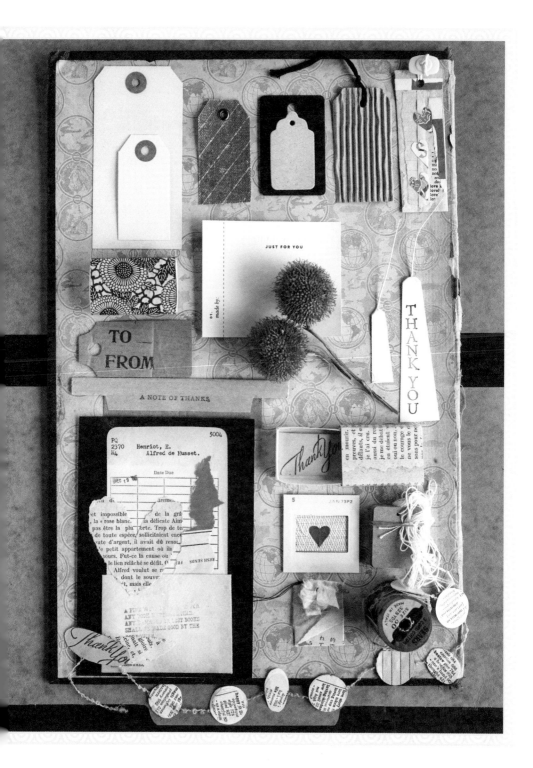

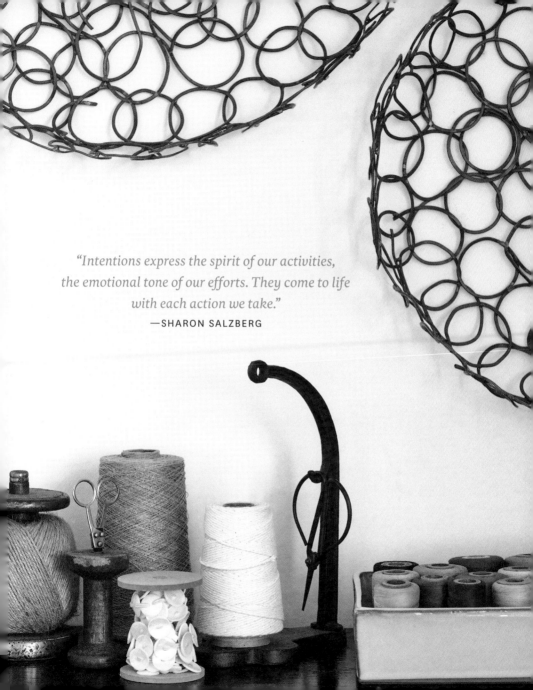

"Intentions express the spirit of our activities, the emotional tone of our efforts. They come to life with each action we take."

—SHARON SALZBERG

# Reflection

My thoughts are with my mother, who passed away many decades ago. I don't think you ever truly get over the loss of someone you love, but the words of the Buddhist priest at her memorial service continue to comfort me. He said we honor the ones who have passed on not with sadness but with feelings of gratitude for what they have given us and continue to give us in their physical absence.

The summer breeze that arrived every year, initiating my mother's ritual of airing out her kimonos, unwrapping and rewrapping, an expression of gratitude to her mother, made its way into my dreams shortly after her passing. I was flying along a lush, airy, green hillside and caught a glimpse of my mother from afar. I could see her sitting in a white tent surrounded by other women brushing her long hair, the light wind creating waves on the softly fluttering fabric of the tent. I felt assured, at peace, as if hearing her voice letting me know she was being taken care of, a discreet nudge telling me to move forward with my life.

My greatest wish is that my mother had met my three children, her grandchildren, and experienced being part of their lives growing up, getting married, having children of their own. When difficult emotions that we can't control surface, being grounded in feelings of gratitude is healing. If you should ever find yourself overcome with grief or sorrow over a loss of a loved one that feels unbearable, I share with you this. Find beauty in the hovering endless pain that doesn't want to leave. It lingers to keep us company rather than to leave us in the loneliness of cherished memories forgotten. It reminds us to live fully in the moment, remembering all that we were given, and helps us to recognize and appreciate the gifts we continue to receive each day.

I'm often asked if it was my mother who inspired my love for wrapping. I know now that she did. Not in a direct way, but her early passing

and my experience losing an irreplaceable kind of love helped me to see my life as a blessing. This was the gift she left behind. I came to feel deep gratitude for all the people and things that bring me joy, support, and care, making sacrifices out of love. I learned to never take these gifts, our treasures, for granted.

My path to gratefulness, to honoring life's gifts, to honoring my mother and the traditions of her Japanese cultural heritage led me to discover the art of wrapping and its hidden meanings. Wrapping our gifts is not the only, or even a necessary, way to practice gratitude. As the poet Rumi wrote, "There are hundreds of ways to kneel and kiss the ground." But I'm actually drawn to his words in the previous line of the same poem: "Let the beauty we love be what we do."

Through writing this book, I've come to experience the soul and spirit of wrapping in its truest and rawest form—as a reminder of what makes life meaningful. Through intentional effort and creativity you can manifest and translate your deepest feelings of gratitude in physical form and share it with the world as a gift. It is a poetic response to the many unrepayable, often unrecognized gifts we are given, such as our body's breath or the extraordinary gift of nature. I hope it will help you to see your life as a blessing. This is the gift I want to leave behind.

Is there someone or an experience you feel grateful for today? I encourage you to wrap your thoughts with your own hands, guided by your inner intuition, and give thanks. Let it be known in a way that best expresses your intentions. Make the activation of your gratitude a regular practice. It is nurturing, giving, and energizing, bringing immediate joy to yourself and others and inspiring a natural circulation and reciprocation of positive energy. In the words of poet Maya Angelou, "The intangible but very psychic force of good in the world is increased."

*"Flower petals fall, but the flower endures.*
*The form perishes, but the being endures."*
—KANEKO DAIEI

# Acknowledgments

I would like to express my deepest gratitude to the people who helped bring this book to life.

To author Beth Kempton, for your mentorship inspiring me to write and craft a proposal from the deepest place within and for offering the most beautiful foreword.

To publisher Deborah Balmuth, for recognizing the gratitude element of my creative practice, making this all happen. To my editor and creative director, Alethea Morrison, I simply could not have done this without your partnership, guidance, advocacy, and exceptional personhood. Alee Moncy, Emma Sector, Tatum Wilson, and the entire team at Storey, it was a gift to meet in person and thank you for all your work behind the scenes.

To photographers extraordinaire Katie Newburn and Erin Ng, the exquisite and expressive photographs speak for themselves. Mars Vilaubi, thank you for shooting the instructions and for the nettle tea.

To my students, workshop participants, and the organizations that invited me to teach and collaborate over the years, the creative spirit you inspired comes through in the book. A special thank-you to those who shared or gifted wrapping materials or provided the flowers from their gardens as seen in the pages.

To my family, dear friends, and beloved neighbors, you are my living treasures. Your support and patience with me while I had to focus attention on completing this book meant more than you know.

To my three children and their spouses, I love you so much. You are my pride, joy, and happiness. To Michael and Joanna, for your enduring love, being there from the beginning, offering photography and professional design support. Maddie, for your daily uplifting calls and together with Alec being my trusted sounding boards. Mel, our soulful conversations and your visceral understanding of the book's intention means the world.

To my mother-in-law, Kyoko, for your nurturing care over the years, together with Bob, and cooking delicious meals especially when I faced deadlines. To my brother, Kaz, for helping me remember childhood details. To my canine companions Rue and Mia, for keeping me company.

My heart and biggest final thank-you is reserved for you, Doug, my husband, for taking on not only the "whatever was needed" role throughout but for being the foundation every day and in every way, making my wrapping, book writing, and blessed life possible.

| To convert | to | multiply |
| --- | --- | --- |
| inches | millimeters | inches by 25.4 |
| inches | centimeters | inches by 2.54 |

| US | Metric |
| --- | --- |
| ⅛ inch | 3.2 mm |
| ¼ inch | 6.35 mm |
| ⅜ inch | 9.5 mm |
| ½ inch | 1.27 cm |
| ⅝ inch | 1.59 cm |
| ¾ inch | 1.91 cm |
| ⅞ inch | 2.22 cm |
| 1 inch | 2.54 cm |

# Index

## MEGUMI LORNA INOUYE

is a gift-wrapping and packaging artist known for sustainable wrapping designs and inventive techniques inspired by her Japanese heritage. She has been featured in *American Craft* magazine and the *San Francisco Chronicle* and on Creativebug, Yahoo! Life, and *The Ellen DeGeneres Show*. She lives in Northern California. Find her online at giftwrapbymegumi.com.

---

"Megumi Lorna Inouye's work inspires me to live more intentionally, connect more deeply with the world around me, and give more freely from my own heart."
—**KAREN OLSON,** editor in chief, *American Craft* magazine